Olympus Modern Classics

Harold Franklin

HOVE FOTO BOOKS

OLYMPUS MODERN CLASSICS

Printed in Guernsey
in the British Channel Islands

by

**The Guernsey Press Company Limited
Commercial Printing Division**
P.O Box 57
Braye Road, Vale
Guernsey, Channel Islands,
G.B. Europe

Tel No. (01481) 45866 Fax No. (01481) 49907

Guernsey Press, Specialist Printers of Paperback Books,
Newspapers and high quality full colour literature

COMPLETE OLYMPUS
USER'S GUIDE

MODERN CLASSICS

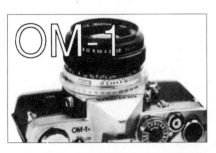

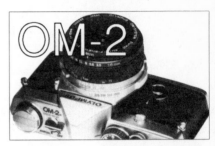

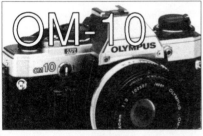

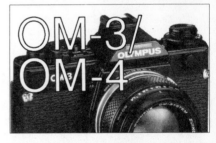

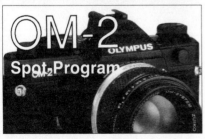

AN ORIGINAL

HOVE FOTO BOOKS **Harold Franklin**

Olympus Modern Classics

First English Edition October 1991
Published by Hove Foto Books
Reprinted January 1993
Reprinted May 1995
Reprinted January 1997

Published by Hove Foto Books Limited
Hotel de France, St Saviour's Road
St Helier, Jersey, Channel Islands, JE2 7LA
Tel: (01534) 614700 Fax: (01534) 887342

Printed by
The Guernsey Press Co. Ltd,
Commercial Printing Division, Guernsey, Channel Islands

British Library Cataloguing in Publication Data
A catalogue record for this book is available from the British Library

Franklin, Harold
Users guide to Olympus modern classics,
1. Cameras

ISBN 0-906447-90-9

Worldwide Distribution

Newpro (UK) Ltd
Old Sawmills Road
Faringdon, Oxon
SN7 7DS England
Tel: (01367) 242411 Fax: (01367) 241124

Contents

Olympus – classics of modern camera technology

Olympus undoubtedly made photographic history with the OM series cameras. The OM-1 was the first mini 35mm SLR camera while the OM-2 was the first to have autodynamic exposure metering (metering at the moment of exposure) and TTL flash metering. The OM-3 and OM-4 twins brought multi-spot metering. The latest model, available at the time of writing as the OM-4 Ti Black, makes it possible to use a 1/2000sec shutter speed with flash. The OM-30 and OM-40, cameras designed with the amateur in mind, were also quite something. The OM-30, for example, was equipped with a system called Zero-In-Focus, which electronically indicated sharp focus, before the launch of the Minolta 7000. On the other hand, the OM-40 had an exposure metering system called ESP which automatically recognised difficult subjects and compensated exposure accordingly.

So there are plenty of reasons for collecting Olympus OM cameras as milestones of photography.

But this book is not meant for collectors. This may sound crass, but the OM cameras are far too good for collectors. These small and precise photographic machines don't belong in the cupboard or display cabinet, they belong in the hands of photographers. They belong to those who can appreciate outstanding technology, but who know that the whole point of having a camera is to take photographs.

The first six chapters of this book describe six Olympus OM cameras now unavailable new, but which can often be seen in the secondhand windows of photographic dealers.

The tracks guide the eye into the depth of this shot.

The camera descriptions are intended to help you get to know the camera, to help you decide before you buy. They will also help you find your way around if you have bought one without an instruction manual. If you read one chapter after another you will re-tread familiar ground because I couldn't re-invent the cameras in order to be able to write something different - I had to stick to what I saw. This is made even more apparent because Olympus places such great emphasis on its system philosophy, where different cameras and lenses share similar design features.

In other chapters you will be introduced to lenses, flash units, motordrives, winders and other accessories. Here I have concentrated on what is currently available because accessories are not often found in secondhand shops. Somebody switching to a new camera, and selling the old one in part exchange, does not necessarily trade in a winder, motordrive or bellows unit at the same time.

If all this is to be accommodated in a paperback it is impossible to cover everything in detail. The extensive Olympus accessory range for microphotography and macrophotography alone could fill a whole book. And if I wanted to describe all the ways of using the different flash units with the various cameras and their metering systems I could fill another book.

All that, and more, was not possible for sheer lack of space.

But I hope that

❑ I can introduce you to six fascinating cameras and do them justice.

❑ I can give you an insight into an equally fascinating system, and whet your appetite for finding out more and exploring it for yourself.

❑ my explanations will help you to find your way quickly around your cameras if you are someone who uses 'yesterday's cameras' as an inexpensive way of getting into a new hobby.

Harold Franklin

Olympus OM-1: a compact SLR provides a great surprise

The Olympus M-1 was introduced at the 1972 Photokina, and came onto the market as the OM-1 in the spring of 1973. Leitz had protested against the model name because their top model at that time was called the Leica M5, a metering viewfinder camera with integral exposure meter.

At the time, Fuji was the first to make light emitting diodes (LEDs) glow in the viewfinder of an SLR camera, and electric contacts for transferring aperture values between the lens and the camera were new in the Praktica LLC. Rollei's A-110, also introduced in 1972, was the most beautiful camera made for 110 film. Vivitar also moved zoom development quite a step forward with its now legendary Series 1 70-210mm,f/3.5.

The Olympus OM-1, which came into the shops in small numbers in the spring of 1973, and its predecessor the OM-1N, which only disappeared from shop windows as a new camera 14 years later, are identical apart from two important alterations.

The first alteration was made as far back as 1974. The camera came supplied with a base plate which allowed a motordrive to be attached directly. This camera is recognisable by a small MD (Motor Drive) label set to the right and below the lens when viewed from the front.

The second alteration turned the OM-1 MD into an OM-1N. The later camera is fitted with a different flash contact, which made it possible for full flash charge to be indicated in the viewfinder.

The pages which follow cover the OM-1N, and the photographs, too, show an OM-1N. If you are toying with the idea

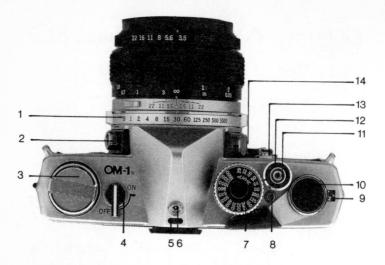

1 Manual shutter speed ring	6 Hot shoe screw socket
2 PC synchro socket	7 Film speed dial
3 Rewind crank	8 Film speed dial release button
4 Main switch	9 Exposure counter
5 Hot shoe contacts	10 Film advance lever

of buying one of the other two variants, or if you have already bought one, the information still applies to your Olympus, except for the two differences already mentioned.

When the Olympus OM-1 is displayed in the secondhand window next to other cameras of its generation it looks quite tiny. This applies not only to professional cameras such as the Canon F-1 but a standard amateur camera like the Nikkormat FTN is also quite a bit larger. If you then weigh the cameras in your hand, you will find that the OM-1 is a very practical companion for photographic trips. It weighs just 700g with the Zuiko 50mm,f/1.8 standard lens attached. If you pick up the OM-1N you will be surprised how well it sits in the hand, and how easy the controls are to operate.

With such small dimensions and such a low weight it is hardly surprising if potential buyers ask themselves whether this small camera has everything a camera of this class should have.

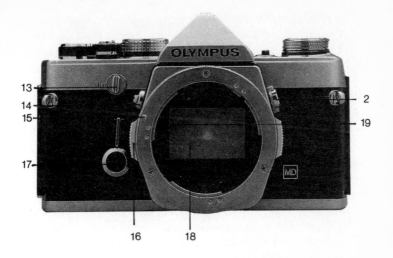

11 Cable release socket
12 Shutter release button
13 Rewind release lever
14 Mirror lock-up button
15 Index for mounting lenses

16 Grip piece of the manual shutter
 speed ring
17 Self-timer lever
18 Instant return mirror
19 Reflection of the viewfinder
 display

Such worries are unfounded. The Olympus OM-1N is a full-blown SLR camera.

Let's have a look at the OM-1. We will proceed in a clockwise direction, starting with the pentaprism housing, and will assume that we are looking at the camera as you would see it when taking photographs, with the lens pointing towards the subject.

The **pentaprism housing** has three openings: a large one for a screw and two smaller ones for thin pins. (The OM-1 and the OM-1 MD only have the opening for the screw.) This is where the **hot shoe** is attached and unlike other SLR cameras, it is designed as a separate component and is not permanently mounted. A plus point is that the camera is neater without the hot shoe. But it has the disadvantage that you have to remember to pack the hot shoe as well as the flash when you are going to take photographs in adverse light conditions.

The **film speed dial** is located to the right of the pentaprism housing. If you had a different camera before the OM-1 you will find this arrangement strange. On most other cameras the shutter speed dial is located in this position, whereas the Olympus designers placed it around the lens mount. The dial for ASA values (ISO values were not yet current when the OM-1 was introduced) is normally locked. In order to turn it you need to hold down the **film speed dial release button** to its right. All values between ISO 25/15° to ASA 1600/33° can be selected in one-third steps. Although this may seem a little narrow in view of the new high speed films now available, it is more than sufficient for everyday photography. You can do quite a lot with films rated between ISO 50/80° and ISO 400/27°. If you plan a long series of consecutive shots for which you want to make an exposure compensation, this is most conveniently done on the OM-1 by means of the film speed selection. The index with which the desired value has to be aligned is engraved in black on the edge of the ring surrounding the shutter release button.

The **shutter release button,** located to the right of the film speed dial on the front edge of the camera, is a normal one-step shutter release which only serves to fire the shutter – the exposure meter is activated by means of a separate switch. The critical point is not very pronounced, but it is noticeable. Press the shutter release button until you feel a slight resistance, and then wait for the right moment for taking the shot. Then just a

The large dial is only used for setting the film speed.

minute movement of the finger with minimal pressure is sufficient to take the photograph. While this approach substantially reduces the danger of camera shake, it is advisable to use a tripod and cable release for slower shutter speeds. The cable release screws into the thread of the shutter release button.

The **film advance lever** can be found to the right of the shutter release button. In the neutral position it lies flush with the camera back, in the pre-advance position it protrudes at an angle of just under 30°, and it travels through 150° to cock the shutter and advance the film one frame at a time. Coupling film winding and shutter cocking in this way prevents accidental double exposures.

The **exposure counter** can be found almost at the very end of the top of the camera, between the front and back edges. It adds up the number of exposures made. When a film has just been loaded, an S is visible in this window, followed by two dots, then the numbers 1 and 2. As you continue shooting even numbers up to 36 appear, with odd numbers indicated by dots. A dot and an E follow after 36. You will also notice that numbers 12, 20, 24 and 36, as well as the S and the E, are shown in yellow because they mark the end of the film for commonly-used film lengths. Before the film advance lever is operated, the exposure counter shows the number of exposures already made, afterwards it indicates the number of the frame to be exposed next. For festivities such as weddings, or events like carnival processions, it pays to keep an eye on the exposure counter. You need to know if there is enough room left on the film to capture an imminent scene in all its detail. If necessary, you should sacrifice the last frames of the film and re-load with a full length.

The **rewind release lever** is located on the right-hand side of the front of OM-1, a little to the left below the shutter release button. When taking photographs, the lever is set vertically with the red dot uppermost. But in order to make rewinding possible, the lever is moved to the horizontal position and the red dot aligned with the red index mark R.

Further down, still on the right-hand side of the camera front, you will notice the **self-timer lever.** It can be used to pre-

The rewind release lever is in a prominent place.

The self-timer lever seems almost too large on the small camera body.

vent camera shake, as well as take self-portraits. The mechanical self-timer is activated by pushing down the large lever when a small lever, used to activate the self-timer countdown, becomes visible. The large lever returns to its original position with a buzzing sound. This takes ten seconds, at the end of which the exposure is made. But the self-timer lever stays down if the shutter release button is pressed and the exposure is made as normal. If the shutter release button is pressed during the self-timer countdown, the exposure is made and the self-timer lever returns to almost its original position. It is activated automatically when the shutter is next cocked, and the shot is taken with a short delay.

The **mirror lock-up button** is located half-way between the rewind release lever and the self-timer lever, to the right of the lens mount. The lever with its black marking is normally in a horizontal position but if it is moved to a vertical position, the mirror of the OM-1 flips up out of the way and stays there until the lever is returned to its original position. By eliminating the mirror movement, there is much less danger of the camera vibrating during the exposure.

For battery loading the cover on the very edge needs to be removed. With second-hand cameras the cover over the motor coupling can sometimes be a different colour.

The **battery chamber lid** with its coin slot can be found to the very right of the base of the OM-1 (with the lens pointing downwards). You can see through a small borehole whether or not a battery has been inserted. The button-type cell is only necessary for exposure metering, since all other functions of the OM-1 are controlled mechanically and it can be used without a battery. Nowadays this is only a real advantage on trips to very remote regions of the world because batteries are available almost everywhere - not to mention the fact that smart photographers always carry spare batteries for their important pieces of equipment.

It is time to change the battery when the movement of the indicator needle in the viewfinder becomes sluggish. When loading it is extremely important that the poles are the right way around. If you hold the OM-1 upside down to load the battery, the + of the battery needs to point upwards!

While the lid of the battery chamber has a screw thread, the lid of the **motor coupling** is equipped with a bayonet which opens with only 1/6 of a turn. It is located slightly to the left of the battery chamber at the front edge of the base of the camera body. The **motor guide pin hole** immediately in front of the battery chamber is also necessary for attaching a motordrive (or winder). A pin on the motor/winder engages here to ensure precise positioning.

The **tripod socket** is sunk into the base of the camera body, but is not found exactly in the middle. It is set near the camera's centre of gravity and is intended to fit 1/4 inch Whitworth thread tripod screws. Although tripods tend to be

Graphic form and nostalgia inspired by the rust makes an interesting subject.

unpopular, they are important accessories, and even a pocket tripod or a monopod can dramatically reduce wastage caused by camera shake.

Two contacts can be found in the left-hand third of the base; these are the **motor coupling terminals** used to transmit data between the camera and the motordrive; for example, to ensure that the film is only wound on when the shutter release process has been completed. (The base of the first OM-1 only has the tripod socket and the battery chamber lid.)

On the left-hand side of the front of the OM-1 only a switch, which has its place on the upper third of the lens mount, is noticeable at a first glance. If you look more closely you will notice that the switch surrounds a plug contact - the **flash socket** which connects to flash units with standard synchro cables. The switch is the **synchro selector** and can be set to two positions. Align it with the X and you synchronise the shutter with electronic flash units, while setting it to FP lets you work with flash bulbs, as long as they are connected via a cable. The centre contact on the pentaprism housing is always synchro-

A slightly tighter exposure - by stopping down the aperture after exposure metering - helps to emphasise the neon letters.

nised for electronic flash units. On the first OM-1 and the OM-1 MD this switch also influences the flash connection on the pentaprism housing.

The guide number still had to be selected manually - the Canon AE-1, the first camera to put an end to this, was still at design stage when the OM-1 was introduced. Electronic flash units can be synchronised for all speeds between 1 and 1/60sec.

The large **rewind crank** and **rewind knob** dominate the left-hand side of the top of the camera. Once rewinding has been made possible by pressing the rewind release lever, the large lever of the rewind crank, which can be gripped securely, is folded out and the film spooled back into the cassette by winding the crank. This will normally happen at the end of the film, but it is always possible to rewind a partially exposed film. The camera can be opened when the crank turns easily after a slight jerk because the film is back in the cassette. To open the back cover, the rewind crank is pulled up, past a point of slight resistance. The back cover clicks open, and you can take the

cassette out easily. The exposure counter jumps back to the S setting when the camera back is opened.

A little further to the right, behind the engraving with the camera name, you will find the **on/off switch** for the exposure meter. By setting the lever to the ON position, you activate a centre-weighted exposure metering system. Through-the-lens (TTL) exposure metering is carried out with the help of CdS cells housed in the camera and with the lens iris diaphragm fully open.

The **manual shutter speed ring** surrounds the bayonet lens mount. Shown in blue, like the X on the sync selector, are shutter speeds from 1 to 1/60sec, plus the B setting. The shutter speeds from 1/125 to 1/1000sec are in black. A shutter speed range between 1 and 1/1000sec controlled by the clockwork mechanism of the OM-1 is therefore available. In addition, there are the slow shutter speeds using the B setting. Whatever shutter speed you select in order to create a shot according to your ideas - you have to select it manually. The aperture, too,

The switch for the exposure meter - don't forget to set it to OFF, otherwise the batteries will become flat quickly.

The manual shutter speed ring surrounds the bayonet.

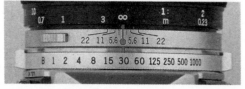

has to be preselected manually because the OM-1 is a camera with match-needle metering or manual exposure control. The manual shutter speed ring is equipped with two obvious, nicely ribbed grip pieces that allow easier handling. This is particularly true when using large diameter lenses on the OM-1.

If there isn't a lens on the camera, you will see the **mirror chamber** from the front, where the instant return mirror and the camera to lens couplings are located. When the mirror is folded upwards you can see the black shutter blind which, like the mirror, you must never touch. Above the mirror chamber is the interchangeable **focusing screen.**

The back cover is easily taken off. A small pin in the upper third of the hinge needs to be pressed down against the slight resistance of a spring. When the back cover is open, you can also see the shutter. Above and below the film window you will see the shiny chrome pressure tracks which help hold the film flat. Two guide pins are screwed in on the left while on older OM-1 models these are complemented by two on the right-hand side. These get in the way if a databack is to be fitted to an older OM-1.

The bayonet is almost the same height as the camera body. The instant return mirror is large, which means that there is no viewfinder vignetting even with long telephoto lenses.

In this case the shadow area was used for focusing, despite the danger of the source of the shadow being unsharp.

On the left inside the camera body you will see the **cassette chamber** for the film cassette while the transport and **take-up spools** are positioned over to the far right. The take-up spool has several slots in it to grip the film leader. When loading it is also important to make sure that the sprockets of the transport spool engage the perforations of the film. If the film has a lot of slack after loading, because you have pulled too much out of the cassette, take up the slack using the rewind crank until the film lies level. Finally, close the back cover and select the film speed on the film speed dial.

Above the back cover you will see the **viewfinder eyepiece** through which you can see the **focusing screen** with the **focusing aids** for focusing and match-needle metering. In the case of exposure control, this is a black bracket with a + sign (top) and a - sign (bottom). The metering needle needs to be aligned in the centre for the exposure - which is metered in a centre-weighted integral method over the entire image area - to be correct. Above the bracket, but outside the viewfinder image, a

The needle needs to be in the centre of the brackets for the exposure to be correct. If it is touching the top or bottom bracket, a half stop over- or under-exposure is impending.

small green light indicates when a system flash unit in the hot shoe is ready to shoot; when this light flickers the flash exposure is correct. This indication is only possible if the flash unit used is computer-controlled, and doesn't rely on making calculations using the flash's guide number. This facility is missing from older OM-1 models.

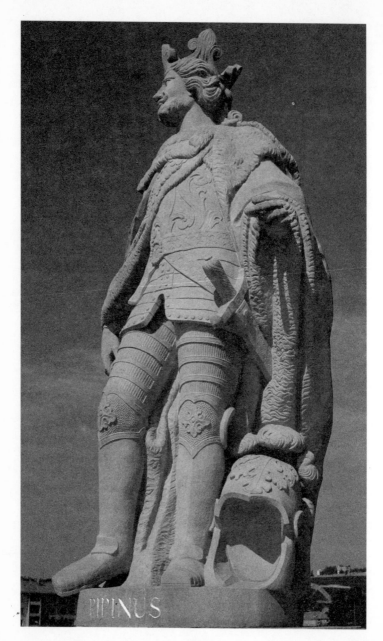

PIPINUS

24

Olympus OM-2: TTL flash metering for the first time

The OM-2 was introduced way back in 1974 and was brought onto the market in late 1975. The first enthusiastic press reports appearing at the beginning of the following year, made amateur photographers throughout the world aware that the uncertainty with flash photography was finally over. You see, the small OM-2 can meter flash lighting during the actual exposure. Even though a great deal was happening in the mid-70s other manufacturers did not have anything comparable to offer. At the same time, Canon launched the AE-1, which sold millions and made the power winder general photographic property. With its K models Pentax said good-bye to the screw thread and moved on to the K bayonet. Leica got together with Minolta and presented the R3, often called 'the best Minolta XE-1 ever'.

There are two versions of the Olympus OM-2. The first is simply called OM-2, the second OM-2N. The later model primarily differs from the first in its flash connection, and eventually has a full flash charge/flash OK indication in the viewfinder. The mirror is also easier to reset on the OM-2N if it becomes locked because the batteries have been loaded incorrectly, or they are weak. An OM-2 is described and shown in the pages which follow. As the differences are only small, you will have no problem applying everything to the OM-2N, if this is the model you have.

The OM-2 is a very small camera and at first glance seems a spitting image of the OM-1. The fact that the OM-2 is still so small is remarkable because it has more to offer than the OM-1.

The main subject is fairly large, so exposure compensation was not neccessary.

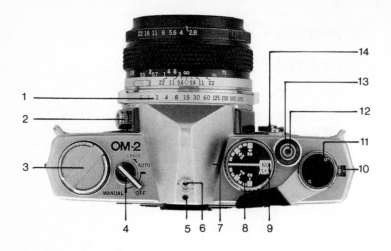

1	Manual shutter speed ring	5	Hot shoe contact socket
2	PC synchro socket	6	Hot shoe socket
3	Rewind crank	7	Exposure compensation marker
4	Mode selector lever	9	Film speed window

Whilst the latter is a mechanical camera with match-needle metering, the OM-2 is an electronically controlled camera with an automatic exposure mode in addition to match-needle metering, and TTL flash metering.

Like the OM-1, the OM-2 sits well in the hand and is great to use. Let's have a look at the controls and the most important parts of the camera. We will start with the **pentaprism housing** and move to the right, with the lens pointing away from the observer. On the pentaprism housing of the OM-2 you will see a screw-in socket for the hot shoe which simultaneously couples the central contact of the **hot shoe** to the camera. A second connection is a contact pin for TTL flash control.

To the right of the pentaprism housing you will find the large **film speed/exposure compensation dial.** In order to set film speeds in a range between ISO 12/12° and ISO 1600/33°, using the engraved ASA numbers, you need to lift up the dial and

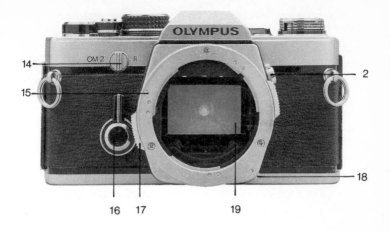

10 Exposure counter
11 Film advance lever
12 Cable release socket
13 Shutter release button
14 Rewind release button

15 Index for mounting lenses
16 Self-timer lever
17 Manual shutter speed ring grip
18 B lock button
19 Instant return mirror

turn it until the desired figure appears in the film speed window. If you can't select a very high or very low figure, you need to let the dial return to its original position and turn it so that the window with the ASA marking points to the right and end the film speed selection process. To set exposure compensation over the range of +/-2 exposure stops available, turn the dial until the relevant marking is opposite the black index line on the pentaprism housing. Compensation is possible in one-third steps. On the OM-2N a small flag in the viewfinder indicates that you are working with compensation, although OM-2 owners must simply remember to reset the dial to its original position when compensation isn't needed.

The **shutter release button,** fitted with a thread for connecting a cable release, is located to the right of the film speed/exposure compensation dial. This feature is worth its weight in gold for tripod shots with long telephotos or macro

Because of the automatic exposure system of the OM-2, the film speed dial is also used to select any exposure compensation factor needed.

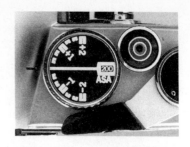

lenses. The shutter release itself has a critical point which is just noticeable. Particularly when using shutter speeds near the limit for hand-held shots it is advisable to hold the shutter release at this point. Only when you reach the right moment for the shot, do you then gently press the shutter release button all the way down.

The **film advance lever** is to the right of the shutter release button. When parked in the neutral position it lies flush with the camera, so there's no way it can get caught in the buttons of your shirt when the camera is round your neck. In the pre-advance position it sits at an angle of 30° to the camera body. In order to wind on the film and cock the shutter - both are coupled to prevent accidental double exposure - you either wind it anti-clockwise through 130°, or inch it to the right in several short strokes until you meet resistance. But in practice there is no good reason why you shouldn't just do it in one go.

Each cocking of the shutter is registered by the **exposure counter,** and the relevant figure is displayed in a small window. This normally means that it shows which frame will be exposed next. One exception is when you switch off the double exposure lock to cock and fire the shutter several times to expose more than once on an individual frame. When a film is first loaded the exposure counter initially indicates S. The unusuable film fogged during loading is wound onto the take-up spool with three blank exposures. Most common film lengths are marked in yellow - except '24' on some early OM-2's - so you know when you reach the end of the film, and don't try to wind on the film by force.

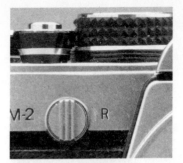

This lever is used to rewind the film.

The self-timer lever - large, bulky and not just important for vain photographers.

The right-hand side of the front of the OM-2 is dominated by two controls. One of these is the **rewind release button** which needs to be turned to the right to allow the film to be wound backwards. For normal use, the red dot on the button points upwards.

The second is the **self-timer lever.** When the lever is pressed down to the right, the mechanical pre-run mechanism is cocked and a small lever becomes visible. Push this towards the lens and the self-timer countdown begins with the exposure made after about ten to twelve seconds if the shutter is cocked. If it isn't, the lever buzzes and returns three-quarters of the way

Battery chamber cover and motor coupling cover are close together - cause for many a mix-up.

back to its original position. As soon as you cock the shutter it starts to run again, and the exposure is made shortly afterwards. With the help of the self-timer photographers can put themselves in the shot, or minimise camera shake in instances when a cable release is not available.

The **battery chamber** is located at the right-hand edge of the camera base and its cover is unscrewed with the help of a coin. It has room for two 1.5V button cells, which must be inserted with positive poles uppermost. The Reset marking draws attention to the fact that the mirror may have locked in its top position because of lack of battery charge, when it needs to be brought back to its original position. On the OM-2 this is done by turning the manual shutter speed ring to the B position. With the OM-2N you first have to load new batteries. To return the mirror to the 'viewfinder position' you simply have to set the mode selector lever to the **Check Reset** position

To the left of the battery chamber cover you will find the cover for the **motor coupling** which can be removed by turning it slightly anti-clockwise. The winder or motodrive engages with the film transport mechanism at this point, and in order for all components to engage precisely, the guide pin of the motor needs to fit into the borehole set in front of the battery chamber.

The **tripod socket** is located in the base of the camera, exactly below the optical axis. If the camera is to stay still during a long exposure, or if very long telephoto lenses can't be hand-held without camera shake, the 1/4 inch Whitworth thread screw is screwed into this socket.

Two **motordrive coupling terminals** are visible in the left-hand portion of the camera base. These control the command flow between camera and motordrive so that film winding can

wait until lengthy exposures are finished. On the other hand, such terminals also ensure that the motordrive works as soon as the second shutter curtain has closed to make fast sequences possible.

The left-hand side of the front of the OM-2 is free of controls. The **PC synchro socket,** which is surrounded by the **synchro switch,** is located on the left-hand side of the protruding lens mount. This connection takes traditional co-axial flash plugs and can be switched to X and FP synchronisation by means of the synchro switch. The connection is important for using studio flash equipment. Off-camera hammerhead flashguns and hot shoe mounted flash units can also be connected to the OM-2. But it is easier to use an Olympus flashgun, or other dedicated TTL units, which can be connected to the hot shoe on the pentaprism housing using a suitable adaptor. The switch is normally set to X-synchronisation where the camera works with electronic flash at speeds of 1/60sec and longer. Long-burning flash bulbs can be used with all shutter speeds between 1/30 and 1/1000sec with the synchro switch in the FP setting, although they no longer play a role in everyday photography.

The **rewind crank** is located at the very edge at the top left-hand side of the OM-2. Once the rewind release button has been pressed, the film can be wound back into the cassette with the crank; this doesn't necessarily have to happen after the last frame. When pulled up, the crank also opens the back cover.

The **mode selector lever** is located between the rewind crank and the pentaprism housing; it locks in three positions and can be pressed into a fourth from which it returns by spring tension.

The mode selector lever should be set to the OFF position when the camera is not used, where it points backwards at a slight angle. OFF means that the exposure meter is switched off and so you can't see any indicators in the viewfinder. Should a unique snapshot opportunity occur when the mode selector lever is in the OFF position, you can still release the shutter and will probably get a correctly exposed shot, provided the light conditions require an exposure of 1/60sec or faster. The

Unlike that of the OM-1, the mode selector lever of the OM-2 should not be pointing to the back when the camera is not in use, otherwise the batteries will run down quickly.

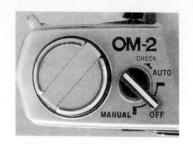

exposure starts when the shutter release button is pressed but the actual exposure metering process is still being carried out - a special feature first introduced on the OM-2. Once the film has been exposed to enough light, the automatic exposure mode starts the second shutter curtain run to terminate the exposure. But as there is no viewfinder display you won't know the shutter speed used.

By pushing the mode selector lever forward by 45° to the AUTO position you switch on the same exposure mode as before with the camera set to off - aperture-priority automatic. This means that the camera determines the appropriate shutter speed based on the brightness of the subject, the film speed and the aperture set. Again this is done during the exposure. But in order to let you know in advance what shutter speed will be used for the exposure, an additional metering sensor is active when the camera is switched on and the reading from this sensor is indicated in the viewfinder which now displays a shutter speed scale.

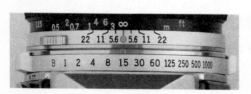

In aperture-priority mode the manual shutter speed ring can be in any position except B - the shutter speed is always controlled by the camera.

Metering is centre-weighted, regardless of whether exposure metering is carried out before, or after, you press the shutter release button.

If you turn the mode selector lever a little further - to the CHECK position - the camera tests the battery performance. The small red lamp of the **battery test indicator** on the back of the camera, located just underneath the mode selector lever, either lights up when there is still enough 'juice' or flashes when it's time to change the batteries. On the OM-2N this lever position is marked as CHECK RESET, and you can release a stuck shutter using the mode selector lever once you've inserted fresh batteries.

If you turn the mode selector lever of the OM-2 to the MANUAL position, you effectively turn the OM-2 into an OM-1 in terms of exposure control. The viewfinder displays the same scale with a + and -, and to obtain the correct exposure you need to the align the meter needle to a mid-point by adjusting either aperture or shutter speed.

The **manual shutter speed** ring of the OM-2 surrounding the lens mount allows you to select shutter speeds from 1/1000sec to 1 second and B. These settings don't work in aperture priority auto mode because the camera determines a suitable shutter speed. It does this over a far wider range and although the top shutter speed remains 1/1000sec, the range of slow speeds is extended up to 120 seconds. In practice the camera often ends up selecting even slower speeds. And although shutter speeds can only be selected in whole steps in manual, aperture-priority automatic allows any intermediate setting that may be required.

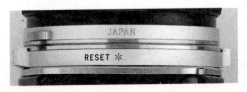

The engraving RESET reminds the photographer that the manual shutter speed ring needs to be set to B in order to release the mirror if it has locked due to lack of power. (This does not apply to the OM-2N.)

Selecting a wide aperture has caused the light patches in the background to be blurred, emphasising the face of the statue.

In order to be able to set the lever to B you have to press the **B lock button** which can be found near the lower left-hand corner of the lens mount and is marked B. As the B setting is also used to release the locked shutter on the OM-2, the word RESET and a red star (*) are engraved at the bottom of the manual shutter speed ring. This corresponds to the indication in the battery chamber, and even if you don't know what this is all about straight away during battery changing, you'll soon remember when you look at the manual shutter speed ring. In the B setting the red star is opposite the B lock button and a small red arrow (<) in order to point to the special function. Thanks to the two large ribbed grip pieces the manual shutter speed ring handles well on all occasions.

When the lens is not in place, you will see the **mirror chamber** with the **instant return mirror,** a characteristic of SLR cameras. Between shots it lies at angle of 45° to the optical axis, so it diverts the light coming through the lens up and onto a focusing screen which can be changed by the photographer himself. Just before the exposure, this mirror flips up out of the

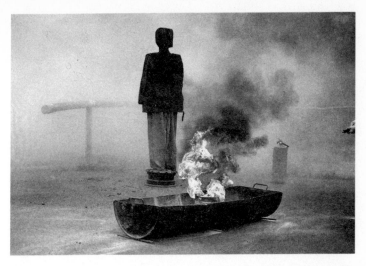

A fire drill. The camera is set to aperture-priority mode, which can cope with all situations.

way, freeing the path for the light to reach the shutter or, when this is open, the film. If you slightly tilt the OM-2, without a lens attached, you can look underneath the mirror to view the shutter behind it. If the shutter isn't cocked you will just see a black cloth, but if the shutter is cocked, a black and white pattern will be visible. This pattern was first introduced on the OM-2 and later became a characteristic of all OM models with automatic exposure.

When you open the back cover you will see the film cassette chamber on the left. The **film take-up spool** with its slots for the film leader is located over to the extreme right while just to its left is the **transport spool,** with sprockets at both the top and bottom. These sprockets engaged with the perforations of the film.

The film window with one of the two **shutter curtains** is visible in the centre and above and below are the **film guide tracks.** These, together with the **film pressure plate** on the inside of the back cover, ensure that the film lies completely flat in the camera. Remember that the film has been wound up in

The red dot on the bayonet is there to help align a lens when mounting it on the camera.

the cassette for some time before being loaded, and has a strong tendency to curl up again in the camera.

It is advisable to switch the OM-2 to MANUAL for film loading and to preselect a fast shutter speed. If you don't, the automatic mode might select a slow shutter speed when you press the shutter release button in order to wind on to the first frame and move unexposed film over the frame. During this process the exposure counter advances from S to 1.

The **back cover** is easily taken off: a small pin in the upper third of the hinge needs to be pressed down against slight resistance. A film back can be used on the OM-2 instead of the standard back cover.

The **viewfinder eyepiece** gives a view of the focusing screen which seems unusually large, as on other Olympus SLR cameras. It is hard to believe that such a large viewfinder image fits such a narrow pentaprism housing.

The **focusing aids** are visible in the centre of the viewfinder image: on the standard focusing screen these are a split-image rangefinder surrounded by a microprism ring.

The tip of the metering mechanism needle protrudes into the viewfinder image from the left when the mode selector lever is set to OFF. As soon as the mode selector lever is set to

The viewfinder image of the OM-2. Left to right: in automatic mode; switched off; in manual mode.

MANUAL, the manual light balance scale already encountered on the OM-1 comes into view with a + sign at the top, and a - sign at the bottom to indicate over- or under-exposure. The exposure is correct if you align the needle mid-way between.

You can obtain correct exposure much more quickly by relying on the automatic mode and setting the mode selector lever to AUTO. The +/- scale moves further to the right and a scale with shutter speed values between 1 second (1) and 1/1000sec (1000) appears instead. Like the manual shutter speed ring, values between 1 second and 1/60sec are marked in blue, while the faster speeds in shown in black. The meter needle points to the shutter speed considered appropriate by the automatic mode and as soon as brightness or aperture settings change, the needle reacts by swinging across the scale. It also does this when you use the exposure compensation facility.

· A red area at the top is the over-exposure warning zone, a corresponding blue area at the bottom warns of likely under-exposure.

The OM-2N has an additional flash indicator above this scale, but outside the viewfinder image. This LED shows whether a dedicated flash unit is ready for use, and whether the flash was able to provide the correct exposure. An additional **compensation warning indicator** - a small black and white signal - on the OM-2N shows that exposure compensation is set and reminds you to turn the dial back to its normal position as soon as compensation is unecessary.

Olympus OM-10: autodynamic metering for beginners

The Olympus OM-10 came on the market in two versions - as the OM-10 and the OM-10 QUARTZ fitted with a fixed databack. This was in the late 1970's, early 1980's and at the time Canon's A-1 introduced automatic exposure programs into the top end of SLR photography, Konica fired the starting pistol for autofocusing with its C35 and Nikon added AI coupling to its old bayonet mount. The Pentax ME-Super was the first camera to replace dials with pushbuttons while the Olympus XA was one of the most inspired compact cameras ever to be introduced.

Following on from the successes of the OM-1 and OM-2, both of which also gained great acclaim in professional circles, Olympus started a second series of SLR cameras carrying two-figure numbers in their name with the OM-10. Olympus aimed these cameras at beginners or amateur photographers who wanted to take good shots in the simplest way possible, and who didn't need professional build quality. For example, the average amateur photographer rarely needs a winder that can race through five shots per minute, so a camera whose mechanics can continually withstand such a pace is unnecessary.

In order to emphasise the difference between the two camera lines, Olympus decided on a slightly different body shape

The sign is illuminated by a few rays of the sun and stands out well from the areas of shadow.

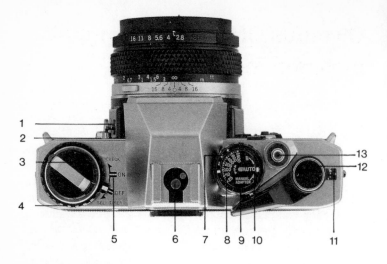

1	Manual adapter guide	6	Hot shoe with flash contacts
2	Manual adapter socket	7	Exposure compensation scale
3	Rewind crank	8	Film speed scale
4	Selector dial	9	Mode selector lever
5	Selector dial scale		

which paid tribute to contemporary taste. The bodies of the 10-series cameras are slightly more angular and they appear bulkier partly because of the larger pentaprism housing with permanently attached hot shoe.

We'll now take a look at the OM-10 and run through its controls one by one. Starting with the pentaprism housing, we will continue to the right, moving around the camera in a roughly clockwise direction.

The more recent OM-10 QUARTZ only differs from the OM-10 in that it has a databack attached as standard; they are identical in terms of light metering and control technology. This chapter will talk about the OM-10, which is also shown in the illustrations.

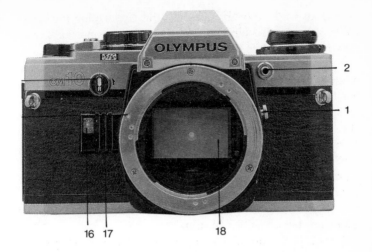

10 Mode selector scale
11 Exposure counter
12 Film advance lever
13 Shutter release button and
 cable release connection

14 Rewind release lever
15 Index for mounting lenses
16 LED for different signals
17 Audible warning system
18 Instant return mirror

The **hot shoe** no longer has to be screwed on as its does on the OM-1 or OM-2 because it is fixed. It has two contacts, a large one in the centre fires any flashgun equipped with a corresponding contact on its foot. The second, smaller contact is necessary for the viewfinder display which includes a flash ready and flash OK function.

The **film speed/exposure compensation dial** is located to the right of the viewfinder window and has a number of functions.

By lifting and turning the outer ring you can select a film speed in the range between ISO 25/15° and ISO 1600/33°. Only the whole ASA value steps are shown, because the numbers are engraved inside the ring, and intermediate steps are shown as dots. The same ring is used to set **exposure compensation** in

a range of +/-2 exposure stops. Do this by aligning the speed value of the loaded film with the desired compensation factor, rather than the white film speed index.

If you have loaded an Ektachrome 100 film, for example, the white index on the ring would normally be opposite the number 100. If you want to achieve a tighter exposure by using the compensation factor -1, the blue number 1 is aligned with the 100 - which in reality corresponds to a new film speed selection of ISO 200/24°. Two other things are obvious once this connection between film speed and compensation factors is clear. Firstly, in order to compensate in one-third steps, you simply select a corresponding higher or lower film speed. For example, you select ISO 64/19° to increase exposure by 2/3 of an exposure stop on an ISO 100 film.

Secondly, the possible compensation factors available for very slow and very fast films is limited because compensation is dependent on the ability to set a faster or slower film speed. Consequently, ISO 1000/30° films can only be exposed with a negative compensation factor of 2/3 of a stop, and for an ISO 25/15° film a positive compensation is not possible.

The **mode selector lever,** which determines the type of exposure control, is located at the back behind the film speed/exposure compensation dial. If you move the lever, a white index dot inside the film speed/exposure compensation dial moves with it. When this dot points to AUTO the camera is set to aperture priority, and when it points to B the duration of the exposure is determined by how long the shutter release button remains pressed. The MANUAL ADAPTER setting comes into play if a manual adapter is fitted to the camera to provide match-needle manual metering, or is useful when using non-dedicated flash units that aren't part of the Olympus system.

The **shutter release button** can be found inside a ring to the right of the film speed/exposure compensation dial and has no critical point. To release the shutter at the right moment, and reduce the danger of camera shake, press the shutter release button until the tip of your finger rests on the edge of the ring. When you want to take the shot, just a small movement is

The mode selector lever of the OM-10 has three different functions: film speed; exposure compensation; main switch.

enough to trip the shutter. The shutter release is equipped with a cable release connection - important for macro shots, for copying, or when using very long telephoto lenses.

The film advance lever over to the right, behind the shutter release button, lies flush with the camera when it is not in use between shots, or when a motordrive is fitted to the camera. In the pre-advance position it sticks out from the camera at 30°. In order to wind on, advance the lever forward in one stroke until it passed through 130° from its original position. If you don't want to be too obvious you can push the lever using small strokes, letting it return to its original position each time. By

The MANUAL ADAPTER setting, with the relevant adapter, allows the automatic camera to be turned into a manually controlled SLR.

A small aperture (which enabled even the stones in the foreground to be reproduced sharply) was selected for this subject, which derives its effect from its symmetry and graphic elements.

coupling film transport and shutter cocking accidental double exposures are avoided. You can't even trick the double exposure lock of the OM-10 by pressing the rewind release button.

The **exposure counter** is connected to the film advance lever. The exposure counter window indicates how many frames have been exposed or, if the film was wound on after a shot, which frame is next. After film loading three blank exposures are necessary in order to prevent spoilt shots. During this process the indication in the exposure counter window moves from S to 1. Make sure that you choose a wide aperture for these blank exposures to avoid the camera setting annoyingly slow shutter speeds. The S for the beginning of the film, the E for the end, as well as the numbers 12, 20, 24 and 36 for the most common film lengths, are shown in yellow. The scale carries on beyond 36 and you can squeeze 37 or 38 shots onto a 36-exposure film with careful loading. But beware that the first

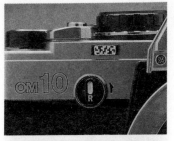

The OM-10, too, still has the rewind release lever at the front of the camera body. The black-and-white pattern indicates that even the simpler OM-10 has the autodynamic metering control system.

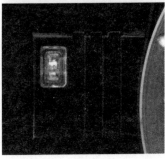

The red LED will flash in several situations (battery check, self-timer countdown). The acoustic signal originating from behind the bars will sound in the same situations.

shot may suffer from fog and perforation damage. As soon as the yellow number indicating the end of the film appears in the exposure counter window, you need to be careful with the winding. Never use force; if you feel resistance wind the film back into the cassette.

To do this set the **rewind release lever,** at the front and below the shutter release button, to the horizontal position. This disengages the transport sprocket in the camera allowing it to turn to backwards for rewinding.

A little further down is a **red LED** set next to three bars. Hidden behind these is the **audible warning system** of the OM-10 which beeps when the battery test is positive, or when the self-timer countdown has started. The red LED, too, lights up or flashes on these occasions.

As on all OM cameras, the battery chamber of the OM-10 is sunk into the base at the extreme right. Once you have

45

As on the other OM cameras, the battery chamber is located at the extreme edge of the camera base. The automatic film transport contact is only there for the winder.

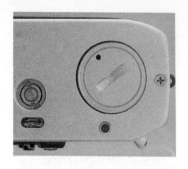

unscrewed the cover using a coin, you can fit two 1.5V button cells. When the camera is turned upside down, necessary for battery loading, the positive poles of the batteries must point upwards.

In front of the battery chamber you will see a borehole which takes the guide pin of the winder - the motordrive can't be used on the OM-10. The winder coupling socket is visible to its left.

The 1/4 inch **tripod socket** allows the OM-10 to be screwed onto standard tripods. This is advisable not only with long heavy lenses, but also whenever you get near or exceed the limit for hand-held shots. Very few professional tripods or tripod heads are fitted with 3/8 inch screws that can't be reduced to 1/4 inch using an adapter.

Further to the left **two winder coupling terminals** are waiting to make the necessary connection between camera and winder.

To the left-hand side of the camera front, you will notice a special mount. It is for the **manual adapter** and above it is a socket where the manual adapter fits. Shutter speeds between 1 and 1/1000sec can be selected manually using the adapter if the mode selector lever is set to MANUAL ADAPTER. Here

The manual adapter is plugged into the socket next to the lens mount. It is used to set the shutter speeds manually, and can therefore be described as a separate manual shutter speed ring.

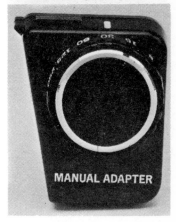

MANUAL ADAPTER

you gain match-needle manual metering. The rather laborious method of shutter speed selection is necessary because the OM-10 is really an automatic-only camera for the beginner. It selects the shutter speed from a continuously variable range from 2 to 1/1000sec, based on the aperture, subject brightness and film speed.

On the top left-hand side the **rewind crank** is surrounded by the **selector dial** which locks in ON, OFF, SELF-TIMER and CHECK positions.

The camera is switched off in the OFF position. It is, of course, switched on in the ON position, but if the selector dial is set to AUTO it works in aperture-priority mode. But it also works in this fashion when the shutter release button is pressed

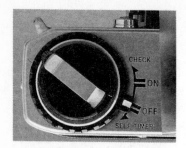

The selector dial is not just used to switch the camera on and off, but also to check the batteries and activate the self-timer.

when the camera switched off. Although there is no display, the autodynamic metering system meters and controls the camera when the shutter opens.

If the mode selector lever is set to MANUAL ADAPTER, and the camera is switched off, the shutter speed selected on the adapter is used when the shutter release button is pressed. Without the adapter fitted the shutter speed set is 1/60sec, the iris diaphragm closes to the value which was selected on the aperture ring and no exposure metering takes place. If you want to save power, you can proceed in this way as long as the lighting is constant, your subjects don't have a lot of contrast and if you have determined a suitable shutter speed and aperture setting at least once.

If you pull up the rewind crank the **back cover** of the OM-10 pops open and you will see, from left to right: the **film cassette chamber;** the **film window** covered by one of the **shutter blinds;** above and below smooth **guide tracks** which, together with the **film pressure plate** on the back cover, hold the film

The integral metering system produces a tight exposure which works well with the play of light and shadows.

flat; the **transport spool** with the two sprocket rings at top and bottom; and the **take-up spool** with slots to accept the film leader. Many photographers work in the following fashion so they don't pull too much film out of the cassette. First, push the beginning of the film into the slotted spool, hold it there and drag the cassette to the left until it slides into the cassette chamber. You should take care not to touch the shutter if you want to load this way.

If you set the mode selector lever to B and press the shutter release button while the back cover is open, you can see the back of the **mirror chamber.** At the centre of the base you will see the large metering sensor which points towards the film plane. Before the shutter is released this sensor registers the light reflected by the first shutter blind which is patterned in typical fashion, but during the exposure it registers the light reflected from the surface of the film. You can't see the **instant return mirror** in this situation since it covers the top of the mirror chamber.

49

The viewfinder image is clear and tidy. The scale on the left is not in the way. The numbers are naturally difficult to see in front of dark backgrounds.

If you look into the mirror chamber from the front without pressing the shutter release button, you can look underneath the mirror at the black and white pattern of the first shutter blind. But note that the shutter must be cocked for you to do this. When the mirror is in the viewfinder position - at an angle of 45° to the optical axis - you can see the non-interchangeable focusing screen above.

A glance through the **viewfinder eyepiece** will give you another view of the same focusing screen which is equipped with a split-image rangefinder and microprism ring.

On the left of the viewfinder image you can see a scale which displays, from top to bottom, shutter speeds from 1 (1) to 1/1000sec (1000), plus a flash symbol in the red area above. No meter needle swings across this scale but instead red LEDs, set on a black background, light up to the left of the scale outside the image area. In aperture-priority mode the LEDs indicate the shutter speed likely to be selected by the automatic program. 'Likely to be selected' because the OM-10, too, has two exposure modes; one works before the exposure to provide the viewfinder display, the other works during the exposure and decides the actual shutter speed used.

In match-needle manual metering mode LEDs indicate which shutter speed the automatic mode would select, and which should be taken as a guide.

If you are using a dedicated flash unit - from Olympus or another manufacturer - the red LED next to the flash symbol

lights up when the flash is fully charged, and flashes if the computed exposure was sufficiently bright. Although 1/60sec is automatically selected as the flash sync speed, an LED lights up next to the shutter speed giving the correct exposure for ambient light. This helps the photographer to control the brightness between the main subject and the ambiently-lit background.

Olympus OM-3/OM-4: metering point by point by point

When Olympus introduced the OM-4 in 1983, it also announced its sister model which didn't actually come onto the market until 1985. When it finally arrived, the OM-3 found itself in a surprisingly different photographic world and got lost in all the excitement going on around it. At this time, autofocus was already known in SLRs with the Pentax ME-F and the Nikon F3-AF but the Minolta 7000 caused caused the most fuss among photographic enthusiasts. What else was happening to photography in 1985? Well, Nikon launched the F-301, an amateur model with integral winder, and Konica presented the TC-X, the first SLR to read the film speed directly from DX-coded cassettes. The Kiron 28-210mm super zoom also caused quite a stir.

But the OM-4 was the more popular of these two sister models and is still available at the time of writing as the OM-4 Ti Black. The OM-4 has an automatic exposure mode and as you would expect from an automatic Olympus, it has autodynamic exposure metering and control. As a result, the first shutter blind has the typical reflective pattern. Its sister, the OM-3, has no such feature because it is a mechanically controlled model with match-needle metering, and is in many ways more like an OM-1 with added features and a more up-to-date design.

Nevertheless the camera body still has the same width and depth as the original OM-1, so you can swap motordrives and winders between old and new models. But if you look close

This shot was taken using spot metering on the blossoms. The aperture was preselected and the shutter speed adjusted by match-needle metering in order to keep the sharpness on the foreground whilst dissolving the background into a little unsharpness. The depth of field preview button found on (almost) all Zuiko lenses is very helpful in this type of situation.

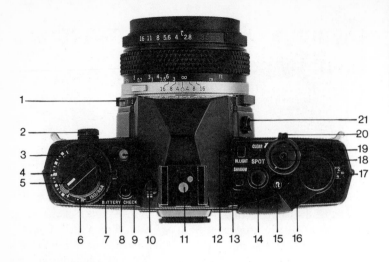

1	Manual shutter speed ring	8	Battery check button
2	TTL flash socket	9	Battery check LED
3	Exposure compensation dial	10	Dioptric adjustment knob
4	Exposure compensation scale		with lock
5	Rewind crank	11	Hot shoe with flash and
6	Film speed window		indicator contacts
7	Acoustic warning signals on/off	12	HI.LIGHT button
	switch	13	SHADOW button

you may see that it's slightly higher than its predecessors because the pentaprism housing is a little larger and some controls are positioned differently. Let's now have a look at the body of the OM-3. If you have an OM-4 in front of you, you'll notice that it's very similar. We'll begin the description of the camera from the pentaprism housing and proceed in a roughly clockwise direction. Unlike the OM-1 and the OM-2, the OM-3 has an integrated **hot shoe** fitted with two contacts. The central contact triggers every flash unit with a central contact, the second contact transmits the data for 'flash ready' and 'flash OK' finder indications from dedicated flashguns to the electronic system of the camera.

The **exposure controls** – four buttons and one switch – are placed to the right of the pentaprism housing.

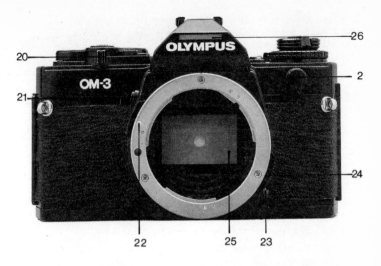

14 SPOT metering button
15 Rewind release button
16 Film advance lever
17 Exposure counter
18 Cable release connection
19 Shutter release button
20 CLEAR lever
21 Viewfinder illumination button

22 Index for mounting lenses
23 PC synchro socket
24 Manual shutter speed ring grip
25 Instant return mirror with the
 surface pattern of the
 secondary mirror visible
25 Viewfinder light window

The largest button is the **shutter release button** which is equipped with a thread for the connection of a cable release. It is a mechanical shutter release mechanism, which starts the shutter release process and all other functions that go to make the exposure, without the help of electromagnets. The shutter release button does not have a particularly pronounced firing point, so to fire at just the right moment without causing camera shake press the shutter release button down until the tip of your finger rests on the ring surrounding the shutter release button. Only slight pressure is then required to trip the shutter.

Light pressure on the shutter release button activates the exposure meter of the OM-3. It works in a centre-weighted integral fashion, and it works differently from the system in the OM-1 because its metering sensor is located at the bottom of

The exposure controls of the OM-3. All buttons are easily found and distinguished, even when the camera is at the eye.

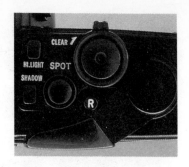

the mirror chamber. It measures the light that is redirected downwards by a secondary mirror hidden behind the semi-silvered instant return mirror.

This type of exposure metering normally produces very good results, but there are times when measuring the overall brightness of a subject doesn't give good results. In this case you can use spot metering, once you know how. Spot metering is activated via the **SPOT metering button** after the shutter release button has been lightly pressed. The SPOT metering button is located behind and to one side of the shutter release button where it's easily reached with the index finger with the camera at eye-level. Spot metering only captures a small 2% of the subject, indicated by the marks on the focusing screen in the viewfinder of the OM-3. The LCD bar graph below the viewfinder image shows the result of the spot metering measurement. One special feature on the OM-3, as well as the various OM-4 models, is that pressing the SPOT metering button several times produces several metering results which are automatically averaged.

Some subjects can't even be handled with spot or multi-spot metering, but need specific exposure compensation. This can be done in several ways on the OM-3. One option is to use the two small rectangular buttons located between the SPOT metering button and the pentaprism housing. If you press the **HI.LIGHT button** an extra one and two-thirds of a stop will make a white subject white in the final shot. Pressing the **SHADOW button** will give two stops less exposure, which

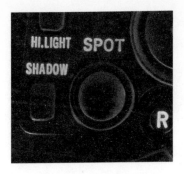

This button is used to activate spot metering.

prevents dark subjects from going grey. Pressing the HI.LIGHT or SHADOW button for the second time cancels the compensation, but not the original spot metering measurement. This is cancelled by pulling the **CLEAR lever,** surrounding the shutter release button, over to the right with your fingertip. The HI.LIGHT and SHADOW buttons can only be used in conjunction with spot metering

The **film advance lever** is located to the right of the exposure metering controls, and is set on a slightly raised platform. From the parked position, flush with the camera, the lever rotates anti-clockwise in one stroke from the pre-advance position to advance the film and cock the shutter. Several small strokes produce the same result, but this approach only slows film winding.

Each operation of the film advance lever causes the indica-

tion in the **exposure counter window** - located to the right of the axis of the film advance lever - to advance one step. The counter indicates S after film loading, and indicates 1 for the first frame to be exposed.

If very bright or very dark subjects are too much even for spot metering, one of these two buttons may help.

Normally the light for the LCD panel enters through the narrow window in the viewfinder. When it is dark outside, the viewfinder displays become difficult to read. The LCD panel can be lit by pressing the viewfinder illumination button.

This is reached only after winding on twice and making two blank exposures. This moves the fogged piece of film, exposed during loading, out of the way and positions unexposed film behind the shutter. The numbers 12, 20, 24 and 36, as well as the E indicating the end of 36-exposure films, are shown in yellow to give a quick impression. When the last frame of the film has been exposed, the **rewind release button** - a small button marked R and located behind the shutter release button - is pressed to allow the film to be rewound.

The only control on the left-hand side of the front of the OM-3 - to the left of the protruding lens mount - is the **viewfinder illumination button.** Viewfinder illumination is switched on by lightly pressing this button, and it switches off automatically after around ten seconds.

The right-hand edge of the OM-3 has a socket, which you may not notice if you bought a secondhand OM-3. This allowed the first owner of the camera to fit an accessory hand-grip. If one isn't attached don't shed any tears because it's small, relatively smooth and doesn't substantially improve handling.

The **battery chamber** for two 1.5 volt button cells is located on the extreme left of the camera base. The battery chamber cover is one that requires a search for the right size of coin to

The five-pole TTL synchro socket is hidden behind this small screw-on cover.

The film speed/exposure compensation dial is set around the rewind crank.

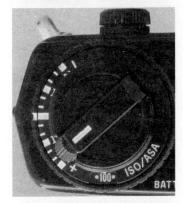

The ASA value of the selected film speed (which corresponds to the first part of the ISO value) appears in this small window.

This is where the compensation factors are selected.

allow it to be opened. The two button cells must be inserted with their positive poles facing upwards. As a mechanical camera the OM-3 can be used without batteries, although the exposure metering won't work. Anyway, the careful photographer always keeps two spare batteries to hand, or also packs a selenium exposure meter which works without any batteries at all, just in case.

The hole for the guide pin of the winder or motor is directly in front of the battery chamber and located to its left is the motor coupling socket. When not used, this is covered by a cover identical to the one over the battery chamber.

The tripod socket is located below the camera's optical axis and is not attached to the detachable camera base but to the die-cast body of the OM-3. Even so, with long and heavy lenses you should still attach the lens, rather than the camera, to the tripod if it has a tripod bracket.

To the left of the tripod socket you will see a **row of contacts,** the motor coupling terminals, to exchange information and commands between camera and motor. Only the Motor Drive 2 requires all these contacts; the Motor Drive 1 and the winders use less.

The **film rewind claw** connected to the rewind crank is only used by the Motor Drive 2. This enables the film to be rewound by the motor giving the photographer time to take the next film out of the photo bag.

The left-hand side of the front of the OM-3 (as always in this book, we are looking at the camera from the shooting direction) is occupied solely by the five-pole **synchro socket** at the top and by the 3mm **PC synchro socket** under the lens mount. Both are important when hammer head flash units are to be used, or when smaller flash units are to be connected to the camera with an extension to obtain better lighting. The PC synchro socket is also needed when the OM-3 is used with studio flash lights.

The **rewind crank,** with the **film speed/exposure compensation dial** set around it, forms the centre of the left-hand side of the camera top-plate.

The film speed/exposure compensation dial is firstly used to set the film speed in a range between ISO 6/9° and ISO

3200/35° - sufficient for nearly every film or situation. Select the film speed by pulling the spring-loaded dial up and turning it until the desired ASA value appears in a window. Since it's combined with the exposure compensation setting, the film speed can only be altered by two whole steps at a time. If you need to adjust it by more you then let the dial slide back to its original position, turn it in the opposite direction, lift it up again and start the process once more. There certainly are better designs, but as this is how the OM-3 is designed, get used to it and remember to check the exposure compensation. After setting the film speed, it may need to be returned to the zero position by simply turning the dial - without lifting it.

If you want to carry out exposure compensation for a sequence of shots, the ring is turned until the index points to the desired value in a range of +/-2 exposure stops. You can carry out exposure compensation in one-third increments, which results in a just visible change in slide films. As film speed and compensation factors are connected, the full exposure compensation range is not available for extremely slow and extremely fast films. However, most commonly used films, from the Kodachrome 25 up to the Ektachrome 400, are well within those limits.

A small lever on the right-hand side of the film speed/exposure compensation dial has nothing to do with film speed and compensation. It simply suppresses the acoustic signals which the OM-3 occasionally uses. When the small lever is pointing to the right you can hear the beep tone for the battery check, can confirm that spot metering, Highlight or Shadow control has taken place, or be sure that spot metering readings are cancelled. If the small lever is pushed forward, the OM-3 will stay silent in every case.

When the camera is set to 'mute', the lever points towards a red LED belonging to the **battery check button** behind it. When pressed, the red LED lights up if the batteries have sufficient charge to ensure correct exposure metering.

A **dioptric adjustment knob** is mounted on the left-hand side of the pentaprism housing, allowing you to adjust the viewfinder optics continuously from +1 to -3 dioptres. A

The small knob on the pentaprism roof is used to adjust the dioptre setting of the viewfinder eyepiece.

viewfinder eyepiece set to the photographer's visual acuity is only a replacement for glasses when the shot is taken. Between shots glasses need to be put on again which means that you're continually taking off your glasses and putting them back on again. It's best not to touch the button at all, because resetting it is difficult due to the lack of a zero setting.

The **viewfinder eyepiece** allows you to view the large **focusing screen** now standard on Olympus SLR cameras since the OM-1. A split-image rangefinder surrounded by a microprism ring can be seen at the centre.

The **LCD panel** is split into four sections. In the upper section you will see a scale with a vertical line indicating the centre. Two arrows point to this index to emphasise it. Two dotted index lines join them either side, and the scale has a + sign at its far left end, and a - sign at its right. The ends of the

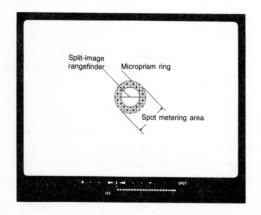

Only the focusing aids are visible in the viewfinder image. All exposure data - except the aperture can be found on the LCD line underneath.

arrows and the index lines divide the scale into eight steps in total. Each step corresponds to one exposure value, a whole shutter speed step or an aperture stop. Below the scale is the second section - we'll skip the third section for the time being - a row of LCD dashes extend from right to left, and can move to different positions. Three dashes fit exactly below one of the steps mentioned, which means that one dash corresponds to one-third of an exposure value. The shutter speed is displayed below the scale (first section), with 2000 for 1/2000sec on the far left and 1 for 1 second on the far right. Only one figure is shown - the selected shutter speed.

The left-hand end of the LCD line lies below the centre of the scale if the shutter speed and aperture selection, film speed and subject brightness all work together to give the correct exposure. If there is a danger of over-exposure, the dashed line extends further to the left. When the line meets the broad end of the arrow the over-exposure is one stop, it is a dash short of the second index line if the over-exposure is two and two-thirds exposure stops, and reaches as far as the plus sign if the exposure would be four exposure values too generous. By the same token an under-exposure by two stops would take place if the LCD line only reaches as far as the second index point from the right. As film speed and subject brightness are usually not variable, you need to adjust the shutter speed and aperture until the tip of the LCD line reaches as far as the middle of the scale.

The third section comes into play when you press the SPOT metering button. A rhombus, showing what the exposure would be for each measurement, lights up each time you carry out spot metering. The length of the LCD line changes as readings are combined because each new average value shifts to a different point away from the correct exposure.

The distances between the rhombi together with the scale indicate by how many exposure values the brightness of the two metering points differ. If you aim at the brightest and darkest part of the subject one after the other, the rhombi will show you the contrast range. When spot metering, or multiple

Spot metering of this blossom with the light shining through it resulted in a frugal exposure of the surrounding area and therefore a clear separation of main subject and surroundings.

spot metering has taken place, you again change the aperture and/or shutter speed until the tip of the LCD line points to the central mark on the scale. Here you have selected an exposure that takes into account all metering points. Whether it does justice to the subject depends on whether you have chosen the right points to measure from.

The word SPOT appears on the right-hand side of the fourth section to show that you are working with spot metering. If you influence the spot metering result by pressing the HI.LIGHT or SHADOW buttons, the words HI.LIGHT or SHADOW appear on the right of the third or first section. In this case a +/- signal will flash at the extreme right of the second section so that you are always aware that exposure compensation has been set.

A green LED is lit continually next to the LCD panel if a compatible flash unit is ready to fire. It flashes if the flash unit was used with computer control and the exposure was correct.

Integral metering was enough for these blossoms. The shot appears even and calm.

The **memo holder** is fixed to the back cover below the viewfinder eyepiece. This is where you can put the ripped-off film box end so that you know immediately after a break from photography whether you've got an Ektachrome 100 or Kodak Gold 400 in your camera. This information is quite important since one is a medium speed slide film, the other a very fast colour negative material.

For you to be able to see your subject in the viewfinder, the light needs to be guided there. This is done by the **instant return mirror** seen if you look into the mirror chamber from the front. If you look underneath the mirror you will see the edge of a secondary mirror which diverts the light to the metering sensor in the base of the mirror chamber.

The **manual shutter speed ring** is located around the bayonet in typical Olympus fashion. Compared to the rest of the camera world, this may seem strange place for the manual shutter speed ring, but it's a very practical one. You can comfortably

hold the camera with the right, index finger on the shutter release button, and select the shutter speed, focus and aperture with your left hand. Your fingers have to wander more or less depending on the length of the lens used.

The shutter speeds from the fastest of 1/2000sec - which is needed only rarely, but still more frequently than the 1/8000sec of modern cameras - to 1/125sec are engraved in white. The speeds from 1/60sec to a full second are engraved in blue, along with B. The white figures show the speeds which usually allow camera shake-free hand-held shots with focal lengths up to 135mm and which can't be used with flash. With blue figured speeds shake is more likely and electronic flash photography impossible. You don't have to press a release button for the B setting.

The interior of the OM-3, which can be viewed through the opened back cover, can be called standard. The **film cassette chamber,** without DX contacts, is on the left. The **film window** with the shutter blind (blind one when the shutter is cocked,

Film loading is fast and safe once you have practised once or twice. The sprockets of the transport spool have to engage with the perforations in the film.

blind two when it isn't) is in the centre, above and below it the four guide tracks, the uppermost and lowest complemented by guide pins. The **transport** and **take-up spools** are located next to each other on the right.

To load the film you simply need to stick the film leader into the slotted take-up spool, hold it, and then pull the cassette over to the left and slip it into the cassette chamber. Afterwards, make sure that the two sprocket wheels of the advance spool grip into the perforation.

A large contact which makes the connection with the databack is sunk in below the transport spool. The **standard back cover,** which is fitted with a large pressure plate, is easily interchangeable. Simply press down the small pin in the upper third of the back cover to detach it.

Olympus OM-2 Spot Program: ADM and Program? It works!

The Olympus OM-2 Spot Program was the last OM-2 model. It was introduced in late 1984 and brought program metering into the Olympus SLR series which sent cold shivers down the spines of many purist Olympus photographers. Yet this type of technology was already quite accepted in other maker's models. Canon introduced it with the A-1, Minolta in a slightly different form on the X-700, Pentax in the super A and program A - which were the competition the OM-2Sp had to stand up against. Apart from that, Photokina 1984 saw lens manufacturer Sigma take an excursion into the camera field, and Canon's Command Back 70 showed how modern electronics allows so much to be crammed into a thin camera back.

At a first glance the Olympus OM-2Sp is clearly a close relative of the OM-2. But if you look more closely, small changes reveal that time hasn't quite passed by this classical Olympus without trace. The pentaprism is wider and rounder, there's a large red LED at the front which catches the eye, and the large selector lever now indicates an exposure mode called Program. This is short for automatic program and means that the aperture as well as the shutter speed is set by the camera. In all previous modes the photographer preselects the aperture value on the aperture ring. In program mode the camera has to be able to close the iris diaphragm to any value, therefore the aperture ring must be set to the minimum aperture value

Spot metering was used for the red background to achieve a balanced exposure. The brighter claws are now clearly separated from the background, which in turn has not disappeared into darkness.

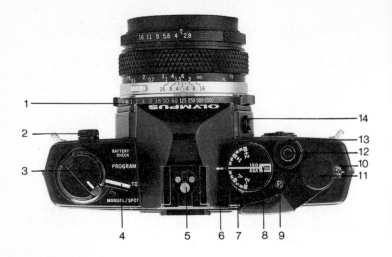

1	Manual shutter speed ring	6	Exposure compensation marker
2	Synchro socket	7	Exposure compensation scale
3	Rewind crank	8	Film speed window
4	Mode selector lever	9	Rewind release button
5	Hot shoe with flash, control and	10	Exposure counter
	indicator contacts	11	Film advance lever

available. The Olympus OM-2Sp fulfils this new task without the need for new lenses and so any Olympus Zuiko lenses can be used on the OM-2Sp without restriction.

Let's look at the OM-2Sp in detail. As with all other cameras in this book, we will start introducing this model from the pentaprism housing and proceed in a roughly clockwise direction. 'Left' and 'right' refer to the OM-2Sp held ready to shoot with the lens pointed at the subject.

The **hot shoe** is permanently fixed to the prism roof. Yet the silhouette of the OM-2Sp appears very small and tidy giving it a more elegant feel than an OM-2 with the hot shoe attached. The shoe of the OM-2Sp is equipped with three contacts. The large contact in the centre triggers all flash units with

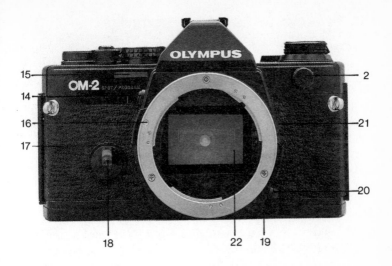

12 Cable release connection
13 Shutter release button
14 Viewfinder illumination button
15 Viewfinder light window
16 Index for mounting lenses
17 Self-timer lever
18 LED for self-timer countdown
 and battery check

19 B and 1/60sec lock button
20 PC synchro socket
21 Manual shutter speed ring grip
22 Instant return mirror with the
 surface pattern of the
 secondary mirror visible

a corresponding contact when the camera is set to MANUAL SPOT. The two remaining contacts are necessary for TTL flash technology and the viewfinder signals if compatible flash units (Olympus T series or other dedicated guns) are used. The **film speed/exposure compensation dial,** largely the same as that of the OM-2, can be found to the right of the pentaprism housing. The **film speed** is selected by lifting and turning the dial. Settings from ISO 12/12° to ISO 3200/33° are available, and one-third steps can be selected. Although the window that indicates the film speed is marked ISO ASA, it only displays ASA values.

Exposure compensation between +2 and -2 exposure values can be set one-third steps by simply turning the dial. Film

Like the first OM-2, the OM-2Sp has a film speed/exposure compensation dial.

speed and compensation factor selection are coupled, which has practical consequences.

Starting from a basic setting of ISO 100/21° and a compensation factor of 0, film speeds from ISO 400/27° to ISO 25/15° can be selected without any problems. This means that the most commonly used films, from the ultra-fine Kodachrome 25 to fast Kodak Gold 400, can be programmed into the exposure meter without any difficulty. But if you want to set a higher value than ISO 400/27°, or a lower value than ISO 25/15°, first preselect these values. Then, let the dial slide back to its original position, select a compensation factor of 0, lift the dial again until you reach the desired value.

But watch out! An exposure compensation is set after each change of the film speed, so always turn the dial back to the zero position to avoid incorrectly exposed shots.

If you have loaded a film that is faster than ISO 800/30°, the range of negative exposure compensation is restricted by one-third of a stop for each one-third increase in ASA value. This means that compensation by between +2 and -1 2/3 exposure stops is possible for a 1000 ASA film, but only positive compensations can be made for a film with ISO 3200/33°. It is the other way around for films below ISO 50/18°. An ISO 40/17° film can have exposure compensation in the range between -2 and +1 2/3, but positive compensation is no longer possible for a film with ISO 12/12°.

The **rewind release button** is located over to the right and behind the film speed/exposure compensation dial. It is a

Compared to the first model, the rewind release button has moved further up. This means that the photographer does not have to worry about pressing it accidentally.

small inconspicuous affair which has to be pressed before you can wind exposed film back into the cassette.

The **film advance lever,** on the other hand, is responsible for winding the film forward and is located at the top right-hand side of the camera body. If it isn't used - perhaps because a motordrive or winder is attached - it sits flush with the body. In the pre-advance position it protrudes from the body at an angle of 30° and a forward stroke of 130° ensures that the film is advanced by one frame and that the shutter is cocked. This combination prevents accidental double exposures but you can trick the camera into allowing double exposures. You can also carry out many small strokes with the film advance lever if you feel it's less conspicuous, but I'm not sure whether it makes much difference.

The **exposure counter** window, seen at the extreme right, counts every film advance, and the row of numbers in the window advances by one step at a time. The S for the beginning of the film, the numbers 12, 20, 24 and 36 for the last frame of a corresponding length of film, and the E for the end of a 36-exposure film are yellow. The S and the two dots before the 1 represent the blank exposures needed for loading.

The **shutter release button** sits nearer at the front edge of the body and between the film speed/exposure compensation dial and the film advance lever. Pressing the shutter release button only releases the shutter if batteries have been inserted in the OM-2Sp. Without them, or when there is insufficient charge, the mirror simply flips up and stays there until your energy problem is solved. Exceptions are the B setting and when you preselect the mechanically controlled 'emergency' shutter speed of 1/60sec. Depending on the position of the mode selector lever, the shutter release button switches on normal centre-weighted integral exposure metering system or spot

73

Light enters through the window above the camera name to illuminate the LCD panel in the viewfinder

metering. This means you no longer need to move between different buttons like you do on the OM-3 and OM-4.

Below the film speed/exposure compensation dial on the top right-hand side of the OM-2Sp is a bright line which catches the eye. This is the **viewfinder light window** which illuminates the exposure scale located to the right of the focusing screen. A prism above it then moves things right and left, turning the reversed image on the focusing screen into one that is the right way around. The prism also causes the exposure scale to appear to the left of the viewfinder looking through the eyepiece. Should the light passing through the light window be insufficient, say in dark surroundings, the exposure scale in the viewfinder can be illuminated. Do this by using the **viewfinder illumination button** positioned below the light window, to the right of the lens mount.

Further down on the right-hand side of the front of the OM-2Sp you will notice a large red switch with a red LED and a small lever at the top. Pulling this small lever upwards and to the right activates the **self-timer** countdown when you next press the shutter release. The red LED flashes, there's a bleeping sound, and the exposure is made after about ten seconds. If the subject changes so an immediate shot is preferable, push the self-timer lever to the centre to make an exposure instantly.

The self-timer is not only a means to appear in the shot yourself, but it also helps to prevent camera shake. The mirror flips up as soon as the self-timer is activated, so slight mirror vibrations can't impair the shot. This is only really significant for

Compared to that of the original model, the self-timer lever is very small. The self-timer countdown is indicated by a flashing LED.

macro or super-telephoto shots at large magnifications. Normally the shaky hand of the photographer is a much greater problem!

If you pull the self-timer lever to the left you switch off the acoustic signals which sound when you check the batteries, or when over-exposure is likely with automatic exposure modes.

Turning the OM-2Sp upside down, you will see the **battery chamber** on the extreme left which takes two 1.5 volt button cells with positive poles upwards.

In front of it you can see the hole for the **guide pin** of a motordrive or winder, and to its left the cover plate of the mechanical **motor coupling.** Three contacts further to the left are the electronic coupling and allow commands to flow between camera and motor. As motorised rewind was not intended, the OM-2Sp makes do with one contact less than the OM-3 and OM-4 models. The 1/4 inch tripod socket is located

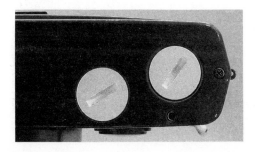

The battery chamber accommodates two 1.5 volt button cells.

underneath the optical axis and the tripod bracket or motor-drive can be screwed in here.

The **B lock button** is situated on the left-hand side at the bottom of the lens mount - press it if you want to turn the manual shutter speed ring beyond the 1 second setting. A little higher up a plastic cap covers a 3mm PC **synchro socket** for connecting normal sync cables to allow normal flashguns, hammerhead flash units or studio flash equipment to be connected to the OM-2Sp. However, the equipment is only activated when the mode selector lever is set to MANUAL SPOT.

The **five-pole OTF auto synchro socket** is intended for the cable connection of T-series flash units; it is located at the top left-hand front side and is normally protected by a small screw-on cap. The left-hand side of the top of the OM-2Sp houses the large **mode selector lever** which rotates around the rewind crank. It moves through three positions and can be pushed against a spring to check battery strength. When you let go, it springs back to the PROGRAM position.

The program mode of the OM-2Sp is very special. Various shutter speed/aperture combinations are made available for different light levels. The aperture is set immediately while the corresponding shutter speed is shown only as a guide in the viewfinder. Just as soon as the exposure has started, the auto-dynamic metering system takes over the job of determining the exact shutter speed. Here it meters the light that enters the

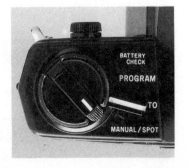

A glance at the mode selector lever will show that spot metering is combined with manual exposure control.

camera - at the aperture setting selected by the program mode - and measures what is reflected by the pattern of the first shutter blind or by the film. As soon as sufficient light has been obtained, the shutter is closed regardless of whether this shutter speed corresponds to that in the viewfinder. The shutter speed range is between 1/1000sec and 60 seconds, and the aperture range is determined by the lens. But you need to remember to set the aperture ring to its smallest value if you want to make every setting available.

The next position on the mode selector lever is marked AUTO, and this switches the camera to aperture-priority mode. This means that you preselect the aperture and the camera determines the shutter speed by means of autodynamic metering which decides when the second shutter blind is to close.

The exposure is metered by a centre-weighted integral method in both program and aperture-priority modes. This means that the brightness of the whole image determines the exposure result, although slightly more emphasis is placed on the central section. This type of exposure metering quickly yields good results with average subjects. If the subject has a lot of contrast, is backlit, is very bright or very dark, spot metering can help - so long as you meter from the right part of the subject. If you want to use spot metering on the OM-2Sp, push the mode selector lever towards back to the MANUAL/SPOT position. Only a small section of the image, bounded by the circle surrounding the microprism ring of the standard focusing screen, will now be used for exposure measurement. The shutter speed/aperture combination resulting from spot metering has to be set manually. The fact that manual setting inevitably takes longer than auto mode only seems a disadvantage at first. You do need to take your time with difficult subjects that can only be handled with spot metering. Manual selection also means that the shutter speed/aperture combination is fixed, particularly important for substitute measurements. The shutter speed range is restricted compared to automatic operation and only runs from 1 to 1/1000sec.

You need to use the **rewind crank** (above the mode selector lever) to wind the film back into the cassette - even if you are

The automatic program is a good choice for wide-angle shots such as this.

using the Motor Drive 2. Although it is capable of rewinding it can only carry it out with the OM-3 and OM-4. By pulling up the crank you can open the **back cover** which hides a standard Olympus SLR interior.

To the right you can see the **film cassette chamber,** in the centre the **film window** with the first shutter blind when the shutter is cocked and the second shutter blind when it isn't. Above and below the film window you will see the **film guide tracks,** two at the top, two at the bottom. The upper and lower tracks are a little shorter in order to make room for two guide pins. The **transport** and **take-up spools** are side by side on the right. The take-up spool has several slots to accomodate the film leader. When loading a film attach the leader first, then pull the film cassette to the left until it slides into the cassette chamber. If the film lifts a little, tighten it with the rewind crank but make sure that the sprocket wheels of the transport spool grip the perforations of the film.

In this shot integral metering has achieved the desired effect of turning the trees into silhouettes in front of the well lit church.

Below the transport spool is the contact that couples with the databack. This is simply connected to the OM-2Sp after removing the standard back cover by pressing down a small pin. Only the **film pressure plate** is worth mentioning on the inside of the standard back cover while the outside has a **memo holder** to take the ripped-off film box ends. You can also fit trimmed pieces of paper into the holder in order to make notes.

The memo holder, for the end flap of the film carton, shows which film has been loaded into the camera, so there can be no confusion even after a long break from photography.

The LCD panel is important in automatic as well as manual mode.

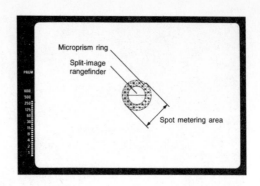

The **viewfinder eyepiece** set above the back cover allows you look onto a focusing screen larger than you'd expect to find hidden under such a small prism housing. The **standard focusing screen,** which can be interchanged with thirteen others, is fitted with a split-image rangefinder and a microprism ring to help you precisely determine sharp focus.

The vertical **LCD panel** to the left of the viewfinder image keeps you informed about the exposure. In PROGRAM and AUTO mode you will see the shutter speed range from 1 (1 second) to 1000 (1/1000sec) on a blue background. The fastest shutter speed is at the top, and in program mode the indication PRGRM is visible just above it. If you haven't selected the smallest aperture and the camera therefore can't utilise the full aperture range of the lens, the autodynamic metering system (ADM) will normally ensure correctly exposed shots despite this incorrect setting but if this is no longer possible, because the subject is too bright and the shutter speed range has been exhausted, the indication OVER appears below a flashing diaphragm symbol. The aperture then has to be stopped down - ADM or no ADM. If the OVER indication flashes, in any other mode, it is too bright for a correctly exposed shot regardless of the type of exposure control - in this case you either have to load a slower film, or use neutral density filters.

Normally an LCD bar graph travels up and down the scale, with its top pointing to the shutter speed to be selected unless the ADM metering system adjusts the exposure. Each dash

corresponds to one-third of an exposure stop so that you can even estimate intermediate values.

The shutter speed scale disappears in MANUAL/SPOT mode, making room for an scale consisting of a zero index with two arrows pointing at it, and a + sign at the top and a - sign at the bottom. In order to achieve a correct exposure with spot metering you need to align the top of the LCD bar graph, which once again travels from bottom to top, with the zero index mark. If you deliberately want to make the exposure longer or shorter, you can go by the arrows as well as the + and - signs. If the LCD bar graph goes as far as the wide end of one of the arrows, the exposure is one stop above or below the correct exposure. If it reaches as far as the + or - sign, you have selected a deviation of two stops.

In this operating mode the LCD bar graph only changes by three rectangles at once because you can only adjust the aperture and shutter speed in whole steps, whereas each dash represents a one-third step.

If you are using a system-compatible flash unit, and have selected one of the automatic exposure modes, a small mark appears next to the 60 when you switch on the flash unit. This indicates that the sync speed is selected automatically but should the exposure metering system come up with a faster shutter speed, the camera will use it and automatically deactivate the flash.

Only TTL flash control is available in program mode because here the aperture is set by the camera. In aperture-priority mode you can preselect the aperture and rely on TTL metering, or set the flash to automatic computer control and select the corresponding aperture when the flash is ready. If the LED flashes after the exposure, the exposure was OK, if the OVER indication is lit up at the same time, the shot was over-exposed and must be re-taken with a smaller aperture. If, on the other hand, the UNDR indication comes on, you need to either set a wider aperture or move closer to the subject to obtain the correct flash exposure.

In MANUAL/SPOT mode 1/60sec is the fastest shutter speed you can select. You can manually preselect all slower

shutter speeds. Faster shutter speeds than 1/60sec would lead to partial exposures because the second shutter blind begins to close before the flash fires, and that part of the film will therefore remain unexposed. TTL flash metering is not possible, but you can use the flashgun's auto computer setting or make a guide number calculation. With any system-compatible flash unit you'll always get a "flash ready" indication, but the OK indication or the OVER and UNDR indications can only light up with the automatic computer setting.

From the viewfinder and its display we will now turn to the front of the camera. When the lens is removed, you can look into the **mirror chamber** and see the semi-silvered **instant return mirror** with the secondary mirror mounted behind to divert the light to the metering sensor in the camera base. By firing the shutter on B, you will be able to make out the secondary mirror at the bottom of the folded mirror, as well as seeing the hollow in the base of the mirror chamber where the **metering sensor** is located. It points backwards to measure the light reflected from the patterned first shutter blind, or from the film surface during ADM and TTL flash metering.

The manual shutter speed ring is once again set around the bayonet. 1/1000sec is still the fastest shutter speed.

The **manual shutter speed ring** surrounds the lens mount. It can be moved in whole shutter speed steps and is divided into three sections. White shutter speeds between 1/125 and 1/1000sec are not suitable for flash exposures, but allow hand-held shots without danger of camera shake at focal lengths up to 135mm. Blue shutter speeds from 1 to 1/60sec are prone to camera shake and are suitable for shots with electronic flash units when the sync speed is manually selected. Red settings

can only be reached after pressing the B lock button, the mechanically set 1/60sec selected when the batteries are empty, and B for manually controlled long exposures. When fully charged batteries are in the camera, both settings can be used for flash with the automatic computer program or after guide number calculation. But with slow speeds you should take into account the fact that the ambient light also exposes the film - the more so, the longer the shutter is open.

Olympus OM-40 PROGRAM: metering over several fields

The Nikon FA, introduced as far back as 1983, was a camera whose exposure metering system used five metering fields. The Olympus OM-40 PROGRAM, which came on the market two years later, also has multiple field metering, but it gets by with only two fields. At the time, however, this type of exposure metering system, which was to become increasingly popular in subsequent years, attracted far less attention than it deserved. It was the autofocus Minolta 7000 which was the centre of attention that year. The OM-30 was more likely to make head-lines in the photographic press, because since 1983 it had proved that it could automatically confirm correct focusing, a fact remembered when autofocus really started. Other photo-graphic news in 1985: Pentax introduced the 645 which combined medium format with 35mm convenience; Konica and Minolta presented compact cameras with two focal lengths; and Tokina went for speed with its 24-40mm,f/2.8 and 35-70mm,f/2.8 zooms.

The OM-40 PROGRAM (simply referred to as OM-40 in the following pages) is the fourth camera in the 'two-figure' Olympus SLR series. The OM-10, OM-20, OM-30 and OM-40 were designed to round off the spectrum of the Olympus system, and to give beginners the chance to use Olympus cameras and equipment. It assumed their demands for professional quality, durability and add-on capacity were not pitched as

Even shots in bad weather can be appealing. The wet figure on the fountain is photographed in aperture-priority mode in order to achieve a compromise between sufficient depth of field and a shutter speed that is fast enough to prevent camera shake.

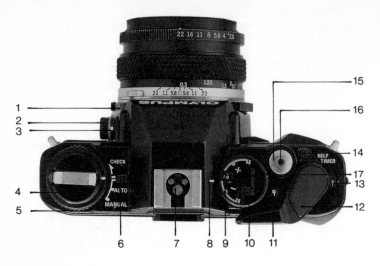

1 Manual shutter speed ring	7 Hot shoe with flash, control and
2 ESP control switch	viewfinder contacts
3 ESP index	8 Exposure compensation/DX-
4 Rewind crank	code marker
5 Mode selector dial	9 Exposure compensation scale
6 Mode selector scale	10 DX/ISO film speed index

high as those of the friends of single-figure Olympus SLR cameras. But it would be foolish, as well as inaccurate, to conclude that the OM-40 is the last of a inferior quality camera range. A cyclist unlikely to explore his limits doesn't need a sophisticated racing bike either, but will be quite happy with a standard touring bike for his excursions.

The OM-40 is a well-equipped camera and even has a little more to offer than other OM cameras, namely automatic DX film speed reading, and ESP - a two-zone exposure metering system which automatically recognises difficult subjects and corrects the exposure accordingly. Let's take a leisurely look at the OM-40, once again following the familiar round trip - starting from the pentaprism housing and around the body in a clockwise direction, with small excursions to one side here and there.

11 Rewind release button
12 Film advance lever
13 Exposure counter
14 Self-timer lever
15 Shutter release button
16 Cable release connection
17 Film speed window

18 Index for mounting lenses
19 LED for self-timer countdown
 and battery check
20 Handgrip
21 Instant return mirror
22 Manual shutter speed ring grip

The OM-40 is equipped with a permanently attached **hot shoe** fitted with three contacts: the firing contact in the centre and two further contacts for TTL flash metering and control, and for communication between flash and camera with dedicated flash units. If you are using flash units with only the firing contact in the centre of the foot, the OM-40 needs to be set to its MANUAL mode.

The **film speed/exposure compensation dial** is located to the right of the fairly wide and flat pentaprism housing. The dial has a setting position which no other previous Olympus SLR camera had - DX ISO AUTO SET. This automatically transfers film speeds from DX-coded cassettes into the electronics of the camera. When the dial is set this way, the film speed value is read from the metal strip on the film cassette and taken as the basis for exposure metering. The range covered by the

The OM-40 is the first Olympus SLR camera to make use of DX-coding technology.

automatic DX program is between ISO 25/15° and ISO 3200/33°. If you want to load a DX-coded film but set another speed than the one on the cassette, you can manually select the desired value in the same range, between ISO 25/15° and ISO 3200/33°. Do this by lifting the dial and turn it until the desired number appears in the film speed window.

Note that you may not be able to achieve very high and very low speeds with the first turn. Let the dial slide back, turn it to the index mark and simply start over again. With manual film speed setting you can simultaneously change the exposure compensation as both are linked. So if you do select the film speed manually, make sure that you reset to zero compensation afterwards, and the film speed window is aligned with the index mark.

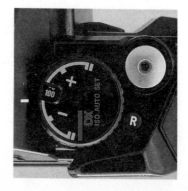

Film speed and exposure compensation factors are combined.

You can input exposure compensation factors of one-third steps in a range of +/-2 exposure stops by turning the film speed/exposure compensation dial without lifting it. Because of the coupling of film speed and compensation factors already mentioned, the range of compensation factors is limited on films with high or low ISO values. Positive compensation of two stops is only possible on films up to ISO 100/21°. Every one-third reduction in speed reduces the setting range of the compensation factors by one-third of an exposure stop. Conversely, the full negative compensation range can only be used if the film speed does not exceed ISO 800/30°. An ISO 1000/31° film can only have a negative compensation of 1 2/3 stops applied to it. If you want to carry out exposure compensation with a DX-coded film, you first set the film speed manually, then carry out the compensation. Leave the manually selected speed as there is no point in going back to DX at this stage. Automatic film speed selection only works if you select the DX program before loading the film. So be careful if you're sometimes a little forgetful.

To the right of the film speed/exposure compensation dial you will find an electromagnetic **shutter release button.** If you press it when the camera does not have sufficient power, the mirror flips up and locks in this position. Only fresh batteries will get the OM-40 going again. A thread for connecting a cable release is sunk into the shutter release button. This makes it easier to achieve shake-free shots at large magnifications and/or slow shutter speeds when using a tripod.

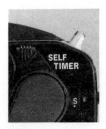

Unlike that of other OM models, the self-timer lever of the OM-40 is not on the front of the camera body, but at the top.

The red LED flashes during self-timer countdown.

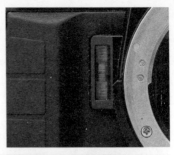

The battery chamber cover can only be opened with the help of a coin. A motor or winder can be connected to the contact next to the cover.

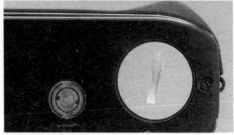

The **rewind release button** can be found right behind the shutter release button. Press this in before you wind the exposed film back into the cassette using the rewind crank.

The **self-timer lever,** sensibly marked SELF TIMER, is over to the right of the shutter release button. Push this lever to the right until it clicks and a red dot appears and then press the shutter release button in order to start the countdown. The mirror will then fold up which makes the self-timer useful for macro or tele shots because the vibrations of early mirror movement will have stopped by the time the first shutter blind runs. If you think that ten seconds before the exposure is too long, you can push the self-timer lever back to its original position, or turn the mode selector dial, to make the exposure immediately.

The self-timer lever returns to its original position when you use the **film advance lever** located behind it. This way you won't miss a snapshot just because the self-timer is set. The film advance lever is used for manual film transport and for cocking the shutter. A 130° stroke forwards is all that's needed once you've pulled the lever to its pre-advance position. You

can combine several small strokes of the lever for one advance/cocking process, but this has no real advantage.

The window of the **exposure counter** is located to the right of the film advance lever. Exposures are added up so you always know how many shots have been taken or, after film winding, which frame is to be exposed next. If you want to know how many shots you have got left, you need to do a little simple mental arithmetic. The S for the beginning of the film, the E for the end of a 36-exposure film and the film lengths 12, 20, 24 and 36 are marked in yellow. When a film has just been loaded the counter is first set to S. Two blank exposures ensure that only unexposed film is advanced to behind the film window for the first shot shown as 1.

The right-hand side of the front of the camera with the rubber-coated **handgrip** is free of controls. A large red LED is all that's found here indicating self-timer countdown by flashing, matched by an audible beep set at the same frequency.

The **battery chamber** with a coin slot cover is situated on the extreme right of the baseplate of the OM-40. The battery chamber takes two 1.5 volt button cells inserted with the positive poles facing upwards. If the mirror has locked up because of lack of power it drops down as soon as the battery chamber cover is fitted onto new batteries.

The hole in front of the battery chamber, the two mechanical contacts to its left and the three electronic contact points in the left-hand quarter of the base plate are needed for a motordrive or winder.

The 1/4 inch **tripod socket** is sunk into the base below the optical axis. It is used not only for screwing the camera to the tripod, but also to attach a motordrive or winder.

The **ESP control switch** is located on the left-hand side of the front of the camera, fairly high up near the protruding lens mount. ESP is switched on if the green dot on the switch is pointing upwards but if the dot is pointing towards the front, ESP is not activated.

ESP stands for electro-selective pattern, that is, selective field metering. In essence this means that the camera meters and evaluates the centre and edge of the image differently during

The ESP control switch. ESP metering can be left on all the time as it is only activated when necessary, in which case this is also indicated in the viewfinder.

exposure metering, so it can automatically compensate exposure for high contrast scenes.

If it doesn't detect high contrast exposure is based on integral metering, and it is when ESP is switched off. In other words, it is quite sensible to leave ESP switched on because it only comes into action when necessary. It is also indicated in the viewfinder so you always know what the OM-40 is doing.

The left-hand side of the top of the OM-40 is occupied by the **rewind crank** and the **mode selector dial.**

The mode selector dial is a ring surrounding the rewind crank. The battery charge is checked when you push this ring forward to the CHECK position and a positive result is announced by a beep tone and the self-timer LED coming on. The ring doesn't click into the CHECK position but returns to the P for program position as soon as you let go.

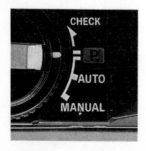

The mode selector dial with the camera's three operating modes: automatic program, match-needle metering and aperture priority.

92

The program exposure mode is based on a system that determines which shutter speed/aperture combination is to be selected in a given lighting situation. On other cameras this combination is usually determined before the exposure is made, but the OM-40 only preselects the aperture since the corresponding shutter speed is only shown in the viewfinder as a guide. The exact shutter speed is selected autodynamically during the exposure.

When the mode selector dial is set to AUTO, you are working with the Olympus aperture-priority mode. You preselect the aperture, the camera closes the iris diaphragm to this value at the point of firing, and selects a suitable shutter speed which may even be corrected when the shutter is open.

In order for exposure metering to work before the mirror is folded up, part of the light goes through the mirror to a secondary mirror and from there to a metering sensor located in the base of the mirror chamber.

You can work with match-needle metering if you set the mode selector dial to MANUAL. The camera does indicate the shutter speed which would be allocated to the selected aperture in automatic mode, but it is up to you which shutter speed you actually select. Match-needle metering is only of interest for gaining the correct exposure if you are working with a manual exposure meter or you wish to fine-tune exposure yourself. The MANUAL mode is also important if you are working with a non-system flash unit with only an ignition contact. In such cases it's up to you whether you use the auto computer function or calculate using guide number with such a flash but remember to select 1/60sec or a slower shutter speed. For the aperture you need to set the aperture ring on the lens according to the auto computer setting of the unit or the value determined by your calculation.

However, it is far easier to rely on the TTL automatic flash program of the OM-40. With dedicated flash units you do this by setting TTL operation, with the OM-40 on AUTO or PROGRAM. If normal exposure with a faster shutter speed is not possible, the sync speed is automatically set at 1/60sec. So sometimes the flash doesn't fire because the shot could be

A still life on a desk: light and dark are evenly distributed, posing no problems for the integral metering system.

taken at 1/125sec without flash. If you still want to use the flash, stop down the aperture until 1/60sec or a slower speed is indicated.

When working in program mode the OM-40 also selects the flash aperture automatically and chooses a setting three stops smaller than the maximum aperture. As this aperture will only rarely be ideal it's better to set the mode selector dial to AUTO. This enables you to make use of the TTL automatic flash program and select the aperture that suits you.

The back cover is opened by lifting the **rewind crank** in the centre of the mode selector dial. What you see behind it differs little from other OM cameras. The most important difference is that six contacts are visible in the **film cassette chamber** for reading the film speed off DX-coded film cassettes. Another feature is the fact that the back cover is permanently attached and can not be replaced by a databack.

As usual you can see the **film window,** which is covered by the first or second shutter blind in the centre. The **film guide**

The iris diaphragm is fully opened to achieve an acceptable shutter speed for a hand-held shot.

tracks are located above and below this window on the OM-40 and together with the film pressure plate on the back cover, these tracks ensure that the film lies flat and therefore avoids unsharpness.

A little further to the right you will find the **transport spool** with two sprocket wheels whose teeth grip the perforation of the film after loading. Finally, the **multi-slot take-up spool** is visible on the extreme right. The beginning of the film is stuck into one of these slots, the cassette is then pulled to the left and pressed into the cassette chamber. If necessary you can tighten the film with the rewind crank before closing the back cover. The back cover makes do without a memo holder. Instead, the **film window** on the left allows a direct view of the film cassette and the manufacturer's inscription telling you about the film type and speed. No light can enter the camera, despite this 'hole' in the back cover, because on the inside, surrounding the window, is thick plastic foam which presses against the cassette to stop light from getting past.

All viewfinder displays are located to the left outside the viewfinder image, which is fully available for assessing the subject.

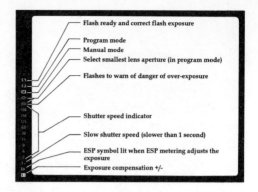

Flash ready and correct flash exposure

Program mode
Manual mode
Select smallest lens aperture (in program mode)

Flashes to warn of danger of over-exposure

Shutter speed indicator

Slow shutter speed (slower than 1 second)

ESP symbol lit when ESP metering adjusts the exposure
Exposure compensation +/-

As on all other Olympus OM cameras, the **manual shutter speed ring** of the OM-40 surrounds the lens mount. The shutter speeds range from a fastest speed of 1/1000sec to a full second which is only the slowest speed in the manual mode. The automatic modes can go as far as 2 seconds but, compared to the slow speeds of other Olympus models, that isn't very long.

If you look through the **lens mount** you will see the **instant return mirror** and, if you look through the small gap underneath it, a secondary mirror. If the shutter is cocked the first shutter blind with its characteristic reflective pattern for autodynamic metering is visible. The **focusing screen** which forms the upper boundary of the mirror chamber is permanently attached on the OM-40.

Looking through the **viewfinder eyepiece,** you will see your subject on this same focusing screen, the right way round. A split-image rangefinder and a microprism ring are there to help focusing. All important data - with the exception of the preselected aperture - are visible in the viewfinder display set to the left of the viewfinder image. The numbers, letters and symbols are on a black background, and as they are backlit they are easy to see.

The shutter speeds take up most of the viewfinder display and show 1000 (for 1/1000sec) at the top to 1 (for 1 second) at the bottom. A small arrow next to the 1 warns of longer exposures. If you are working in aperture-priority or program mode, the shutter speed likely to be automatically selected by

the camera is shown - pending a correction by the ADM system. Above the shutter speed scale an M is lit if you have selected match-needle metering, and a P if you are in program mode. In the latter case an aperture symbol and the 1000 will flash alternately to warn you if you have not set the lens aperture to the smallest value. If the automatic program can work within the limited aperture range between the widest aperture and the value selected on the aperture ring the warning will not appear.

A flash symbol may be visible at the very top. It lights up when a system flash unit is ready to flash, and flashes when the flash exposure with such a flash was correct, regardless of whether auto computer operation or TTL metering was used.

Finally, two symbols below the shutter speed scale indicate the fact that exposure compensation was carried out. The +/- symbol flashes if a compensation factor was manually selected and the ESP symbol lights up as soon as ESP metering detects high contrast and the exposure is automatically adjusted by a suitable amount.

Exposure metering – how bright is it out there?

Obtaining the correct exposure is important for every shot. But how do you work it out precisely? And is the exposure indicated necessarily right for the subject? Olympus offers various interesting forms of exposure metering, and many possible ways to vary it to achieve a certain effect.

All Olympus cameras offer TTL exposure metering. But how does it work?

TTL - metering in the camera

TTL is short for 'through-the-lens', which simply means that measurement is made once the light has entered the camera through the lens. One obvious advantage of this type of exposure metering is that it is always works over the same angle of view as that of the lens, which allows it produce a more suitable result for the lens in use. There are exceptions but these will be covered later in this chapter.

Stop-down metering, working at the taking aperture, was in common use when TTL metering started to be accepted. This means that when a particular aperture value is selected on the aperture ring, the iris diaphragm immediately closes down appropriately before metering takes place. This has the disadvantage that the viewfinder image darkens and not much of the subject is visible with very small apertures, like f/16.

Open-aperture metering - the viewfinder stays bright

Open-aperture metering, used in the OM cameras, puts an end to this problem. The iris diaphragm stays open during

exposure metering and is only closed to the value set on the aperture ring - or that deemed suitable by the program mode - when the exposure is made.

This sounds simple, but it's not quite so easy in practice because the taking aperture mustn't be ignored. Therefore, both the camera and the lens have to be designed for open-aperture metering, so that the aperture value selected on the aperture ring can be taken into account for exposure metering, before the iris diaphragm is closed down. OM cameras and suitable lenses, and other accessories attached to the bayonet mount, therefore use aperture simulator levers. This means that the viewfinder image of your OM camera stays bright and clear right up until the moment of exposure, when the camera registers the light entering through the fully opened iris diaphragm. But the value selected on the aperture ring is taken into account when metering, and the exposure metering result is adjusted accordingly.

This very useful technique can lead to misunderstandings when you use the depth-of-field preview button and look at the viewfinder display. By closing the iris diaphragm to the preselected value, the camera - depending on its features - displays a slower shutter speed in automatic modes or asks you to open the aperture further with match-needle metering. Why? Because when the camera is set to open-aperture metering, it thinks that the smaller diaphragm setting obtained by checking the depth-of-field is the widest aperture of the lens. So it assumes that the maximum amount of light enters at this aperture, and expects the iris diaphragm to be closed further for the exposure. It therefore quickly recalculates the metering result and you should ignore - momentarily - the viewfinder indications.

For the OM cameras with match-needle metering, the OM-1 and OM-3, the problem area 'working aperture metering/ open-aperture metering' ends. This is not the case for Olympus OM cameras with auto exposure control which use the Olympus 'autodynamic exposure metering and control' system, or ADM for short.

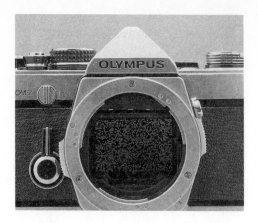

If you look through the bayonet of an OM-2 after the mirror has locked, because the shutter release button has been pressed although no batteries are in the camera, you can see the first shutter blind with the characteristic ADM pattern.

ADM - metering while the shutter is open

Open-aperture metering is only used on these cameras for preview metering to provide a viewfinder readout. Then actual exposure metering, which controls the amount of light reaching the film, is measured at the working aperture. The light entering through the stopped-down iris diaphragm is evaluated when the instant return mirror has swung up and where it is reflected off the film plane onto the metering sensor.

The film plane is where the first shutter blind is located, which is normally black and therefore non-reflective in most cameras. But Auto OM cameras use a first shutter blind with a white pattern printed on it. The peculiar pattern of white spots on a black background does have a method to it. At the time Olympus claimed that thousands of photographs had been evaluated in order to come up with a pattern which imitates the contrast distribution of an ideal photograph. Anyway, the net result is that the patterned shutter blind allows the camera to have very even centre-weighted average exposure metering. When the exposure starts, the first shutter blind uncovers the film and then the second shutter blind runs after a certain amount of time in order to cover the film gate again. If the second blind doesn't run until the first blind has completely

100

cleared the film window, only film covers the film window. This period of time can last for up to about 120 seconds on the OM-2. In order to ensure that this long exposure is correct, the light reflected from the film plane is metered. Should more light suddenly reach the film - because a lamp was switched on for example - the exposure comes to an end earlier than planned. Should less light illuminate the subject - because a lamp was turned off - the exposure is extended until sufficient light reaches the film. In both cases the autodynamic control system influences the exposure while it is taking place and the viewfinder display no longer agrees with the exposure given. This is because the display is dependent on open-aperture metering, carried out before the shutter was released.

Different metering sensors are built into the OM-2 and OM-10 for the two separate exposure metering systems. One measures the light reaching the focusing screen and feeds the result into the viewfinder display. Another metering sensor is located in the base of the mirror chamber and meters the light reflected off the film or shutter blind. The OM-2Sp and the OM-40 work with just one metering sensor housed in the mirror chamber. In this case, just before the exposure is made the sensor picks up light via a secondary mirror mounted below

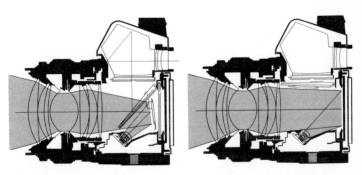

On later OM models a secondary mirror directs the light to the metering sensor in the base of the camera before the shutter is released. When it is released, this sensor registers the light reflected from the first shutter curtain or by the film surface. The full amount of light entering the camera is registered for integral metering.

the semi-silvered main mirror. Once the mirror has swung up, this metering sensor registers the light reflected from the shutter blind or film plane.

On the manual OM-1 and OM-3 models, exposure metering ends when the shutter release button is pressed and the camera uses the values selected on the aperture and shutter speed rings. On the OM-1, the metering sensor is located in the viewfinder system, as was common at the time. The OM-3 on the other hand, has a metering sensor in the base of the mirror chamber and is therefore fitted with a secondary mirror.

The guideline - the norm subject is 'grey'

There are different variants of TTL metering. Of those Olympus offers centre-weighted integral metering, spot metering, multi-spot metering and the automatic contrast comparison ESP. More important than the differences between these metering methods is what they have in common - they are standardised to a normal subject which reflects 18% of the light falling on it. In other words it's a mid-grey. To avoid misunderstanding I should point out that there are also coloured areas which reflect 18% of incident light. So where we are talking about a 'mid grey' in the following pages, we could just as easily say a medium green or a mid brown part of the subject when it comes to exposure metering.

Many subjects correspond to, or approach, the grey tone with a reflection capacity of 18% if their different light and dark components are averaged.

The exposure meter tries to get the subject to be reproduced as such a mid grey on the film by selecting a suitable exposure value based on film speed set. As long as the subject corresponds to this selection everything is OK. If the medium grey subject is lit by bright light, the exposure meter suggests a high exposure value, with correspondingly small apertures and/or fast shutter speeds to ensure correct exposure. If this isn't possible, an over-exposure warning is given. If the medium grey subject is dimly lit, on the other hand, the exposure meter

suggests a low exposure value and the use of wide apertures and/or slow shutter speeds to allow sufficient light to reach the film to give the correct exposure. If this is not possible the camera gives an under-exposure warning and you can compensate by using artificial light like flash.

All of this usually works well because, as already mentioned, most subjects correspond to the medium grey value in their distribution of light and dark parts.

Problem cases - the exposure meter selects the mid value

Problems crop up when a subject steps out of the line, where it has large light or dark sections, or when it is very bright or very dark overall.

Such problems, which often produce the most interesting shots, can also be handled easily when you know how. You can use the relevant Olympus technology, or take things into your own hands by setting exposure compensation - also easy to do with the OM cameras.

If the subject reflects more light than is typical, the exposure meter suggests the same exposure combination as it does for a brightly lit normal subject - a high exposure value. Depending on the type of subject, this can have different consequences. If the whole of the subject is bright, it is reproduced too dark, so a completely white subject becomes grey. If a large bright area - such as the sky - dominates the shot, it is rendered darker due to under-exposure and the main subject may appear only as a silhouette.

Another problem of this type is a high contrast subject with many small, very bright parts - water with specular highlights from the sun, for example. In the photograph the whole subject will appear too dark and details, such as a boat on water, disappear in the darkness.

The remedy is to give more exposure in order to make the bright subject appear bright, and save dark sections of the subject from disappearing.

Integral metering has caused the main subject, the church spire, to be reproduced too dark. A plus compensation achieves a more generous exposure and makes for a better shot of the spire.

Things work back to front in the opposite situation. If the scene reflects less light than a normal subject, the exposure meter suggests a lower exposure value to compensate for the assumed dim lighting conditions. As a consequence very dark subjects are reproduced too light (grey) and small, bright subjects set against an overpowering dark background seem far too bright, lacking in contrast, and faded.

Less exposure will help to re-instate the subject and render it as it should.

Subjects difficult to expose correctly because they're too bright or too dark always require compensation. The amount of compensation required is best determined by metering, rather than guesswork, if you want to achieve spot-on results.

How the compensation is determined, and how it is applied, depends on the features of your camera.

Integral metering - everything is important

Integral metering evaluates the brightness of the entire image area and is ideal for shooting normal subjects. Here you can work very quickly, and leave the automatic metering to take control of shutter speed and/or aperture settings.

In the case of difficult light, try to limit the metering area by selecting a longer focal length setting or move in closer to the subject. Cut the very bright or very dark sections of the subject out of the viewfinder, and meter from a part of the subject which seems roughly mid-grey. It doesn't have to be a grey tone - a medium green, red or blue also reflects about 18% of the incidental light. If you can't find a mid-grey section in the actual subject itself, look for a substitute subject which does. It does, however, have to be lit by the same light as the actual subject. But if a substitute can't be found, Kodak among others, supply so-called grey cards which act as portable substitute subjects for exact exposure metering.

Only a small proportion of the light entering the camera is used for spot metering.

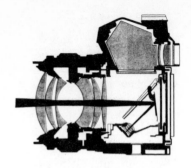

Spot metering - exposure metering right to the point

Spot metering instantly determines the exposure of a very small section of the image area and so the trick of using longer focal lengths or shorter shooting distances becomes redundant. On suitably equipped OM cameras the spot metering field comprises the circular area occupied by the split-image rangefinder and the microprism ring - around 2% of the total image area. So spot metering allows you to use one point to determine the exposure of the whole shot. This does mean that you have to think carefully about which part of the subject is suitable as a metering point, but this is less difficult than often suggested. You just have to know what you want, and remember that a mid-grey subject is the basis of spot metering.

If the whole subject has a lot of contrast but is lit by even light, you should use spot metering to meter a portion which reflects roughly 18% of the incident light (mid-grey, blue, green etc.) and use the exposure settings determined. The whole subject will then be lit correctly - contrast range of the film permitting. If the lighting is high contrast, you can use spot metering to determine the highlight exposure - which means that the shadows will be too dark in the shot - or you can take a shadow reading which results in over-exposed highlights. Or, better still, meter highlights and shadows, one after the other and take an average. But this only makes sense when readings are taken from a mid-grey portion of the subject.

Multi-spot metering - an integral pocket calculator

Multi-spot metering takes over the mental arithmetic of calculating average values by combining the different metering results straight away. This is very convenient, particularly if you are working with more than two metering points. This multi-spot metering system can combine up to eight metering results, although there's no necessity to use all of them because eight spot metering results are nothing else than an unnecessarily complicated form of integral metering. Three or four metering points, on the other hand, are often an effective way of getting better exposed shots. The metering points don't all have to be in different parts of the subject. If you meter a shadow area twice but a light area only once, you get a result that places more emphasis on dark tones than light tones. But the bright subject areas will not be so over-exposed as they would be if only the shadows had been metered.

Compensating - the exposure is in your hands

Neither integral nor spot metering will help you if the subject is very bright or very dark if you can't find a standard grey substitute subject. Here you will always have to correct the metering result. A positive exposure compensation by one to

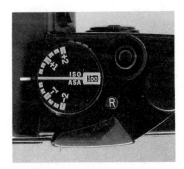

Sometimes the exposure metering system needs the help of compensation factors.

The light background means that the whole shot is dark. The boy is reproduced far too dark. Multi-spot metering produces a better shot.

A plus exposure compensation was needed to brighten up the interior of this church.

two exposure stops on a bright subject and a negative compensation by one-and-a-half to two-and-a-half exposure stops on a dark subject can work wonders.

On cameras with match-needle metering like the OM-1, compensation is set via the shutter speed or aperture setting. Or, if a number of shots need to be fine-tuned simply preselect a slower film speed for a positive compensation, or a faster speed for a negative compensation.

On automatic cameras like the OM-2, OM-2Sp, OM-4, OM-10 and OM-40, the exposure compensation factors influence the exposure.

The manually controllable OM-3, which also allows multi-spot metering with automatic average value calculation and exposure compensation at the touch of a button, takes on a special position in this context. The HI.LIGHT button makes for a more generous exposure of bright subjects, the SHADOW button produces a tighter exposure for dark ones.

The OM-40 is the only Olympus SLR camera to offer ESP metering.

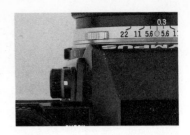

ESP - comparative exposure metering

The ESP metering system of the OM-40 is also something special. Essentially, it is integral metering and spot metering combined where the brightness of the entire image area is compared to the centre. If the camera detects a lot of contrast, it automatically increases exposure if the surrounding area is brighter, and reduces exposure if the surrounding area is darker. The designers of this system assumed the main subject is usually set in the middle of the frame and must be exposed correctly. Admittedly, such centralised picture composition is common, but the system is not always ideal. So if you want to place your main subject at the edge of the shot, remember to do without ESP. Instead, use match-needle metering and take a reading from close in to the subject if you think that the subject can't otherwise be evaluated correctly.

But ESP can do something else. If the subject is very light, the standard integral metering system assumes that it is just brightly lit and so tries to stem the flood of light with fast shutter speeds and small apertures, making the shot grey. Conversely, the exposure of a very dark subject will also go wrong. But the Olympus designers have put a little more 'photographic intelligence' into ESP and so from certain exposure values onwards - clearly above and below the norm - ESP assumes that there is not too little or too much light. Instead it 'senses' but that it is dealing with high or low subject reflectance which needs to be given more or less exposure.

Exposure control – more than just convenience

Gaining the correct exposure is the first important consideration for bagging a good shot. It doesn't matter whether the exposure is obtained manually or by means of an automatic program, just so long as long as it is correct. But you can influence things further by choosing the right type of exposure control, the right shutter speed or aperture.

Exposure value - many matching pairs

Two factors are matched during exposure metering - the brightness of the subject on the one hand, and the film speed on the other. The result is an exposure value (EV), sometimes also called light value (LV). The exposure value has many matching pairs consisting of a series of shutter speed/aperture combinations all resulting in the same exposure of the film. Let's assume the exposure is metered on a nice summer afternoon using a film with ISO 100/21° rating. An exposure value of 13 could, for example, be suitable. This is satisfied by the shutter speed/aperture combinations overleaf.

If the smallest lens is f/22 and the camera's fastest shutter speed is 1/2000sec, you can work at an exposure value of 13 with all the shutter speed/aperture combinations enclosed by the two lines. The reason why all combinations produce the same exposure value is to do with the fact that shutter speeds and apertures follow certain laws. (Incidentally the other combinations aren't pure imagination. Large-format lenses can be stopped down to f/128, and some 35mm cameras offer a shutter speed of 1/8000sec.)

Each shutter speed allows half as much light to reach the film as the next slower one, and twice as much as its faster

neighbour. This means that 1/60sec allows twice as much light to reach the film as 1/125sec, and only half as much as 1/30sec. Each aperture, too, allows half as much light to reach the film as the next wider one, and twice as much as the next smaller one. This means that an aperture of f/5.6 allows twice as much light to pass through the lens as f/8, and half as much as an aperture of f/4. (We'll cover the strange arithmetic of f/5.6 being twice as wide as f/8, and half as wide as f/4 in the chapter on lenses.) Whilst all shutter speed/aperture combinations of a particular

2 sec	at	f/126
1 sec	at	f/90
1/2 sec	at	f/64
1/4 sec	at	f/45
1/8 sec	at	f/32
1/15 sec	at	f/22
1/30 sec	at	f/16
1/60 sec	at	f/11
1/125 sec	at	f/8
1/250 sec	at	f/5.6
1/500 sec	at	f/4
1/1000 sec	at	f/2.8
1/2000 sec	at	f/2
1/4000 sec	at	f/1.4
1/8000 sec	at	f/1

exposure value produce the same exposure, the shots produced by the various combinations differ substantially. This is because shutter speed and aperture have a greater influence on a subject than simply gaining the correct exposure.

The shutter speed - how to control movement

The shutter speed controls the movement of a subject. A fast shutter speed freezes it, a slow shutter speed produces blurring effects that make movement obvious. What can be called fast or slow depends largely on the speed of the subject. Shoot at 1/60sec and you will produce a sharp shot of someone walking, but you'll need to choose 1/125sec or even 1/250sec for children at play or for cyclists. Cars need 1/500sec, and around 1/1000sec is about right for a racing car or an ice hockey player whizzing close by. When judging the best shutter speed you also need to take into account the direction of the moving subject. You can get away with a slightly slower shutter speed if the subject is moving directly towards the camera, but faster

The shutter speed determines how movement is reproduced: the slower the shutter speed, the more blurred the waterfall becomes.

113

shutter speeds are essential with movement across the camera. Also be aware that movement near the camera requires faster shutter speeds, but you may be able to get away with shutter speeds one or even two steps slower for distant subjects.

Slower shutter speeds imply movement thanks to blurring unless you pan with the subject. When panning choose a slower shutter speed of 1/30sec or less and move the camera with the subject as you make the exposure. This can be difficult as the subject becomes invisible while the mirror is up. When you do finally master the technique, after several failed attempts, you'll be rewarded with sharp shots set in front of a streaked, blurred background. A tripod or monopod with a pan head is useful for this technique.

But the shutter speed also minimises the movement of the photographer. In other words, selecting the right shutter speed is an important factor in avoiding camera shake, which probably spoils more shots than poor focusing.

The danger of camera shake is that it's greater at longer focal lengths but a rule of thumb comes to the rescue. The slowest shutter speed recommended for hand-holding should match the reciprocal of the lens focal length. In other words:

Shutter speed = 1 / focal length

If in any doubt, round the shutter speed calculated to the nearest faster speed because nobody's hands - barring professional sharpshooters - are as steady as they think. If you can't achieve this shutter speed, try to rest the camera on something solid or, better still, bolt it to a tripod.

The aperture - how much should be sharp?

The aperture controls the depth of sharpness in a photograph. A lens can be focused only on one plane but in front and behind this plane is the depth-of-field zone, which becomes more shallow as you open the aperture, and deepens as you stop down to smaller apertures. There are other important factors covered later in connection with lenses, but the above applies to the aperture.

Often we try to get the whole subject sharp which means that you will aim for a small aperture. This is fine for landscape, groups and interior shots, overviews of squares or for architecture. But many subjects are better photographed with a shallow depth of field, using selective focusing, because the sharp subject jumps out from its unsharp surroundings. Subjects suiting this treatment include portraits, close-ups of flowers or leaves, animal character studies, sports shots or any detail you want to separate clearly from a larger scene.

Match-needle metering - manual exposure

Depending on the effect you want to achieve, match-needle metering mode allows you to preselect the best shutter speed and aperture combination. If exposure compensation is necessary, first select the correct exposure and then adjust shutter speed or aperture as required. Exposure compensation for several shots with different shutter speed/aperture combinations

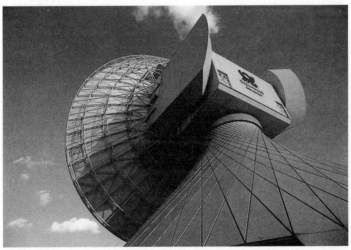

A small aperture produces a huge depth of field, particularly on super wide-angle shots.

115

For many shots with effect filters it is advisable to meter the exposure in advance and set the shutter speed and aperture manually. This way the filter effect, here created with a Cokin speed filter, does not confuse the exposure metering system.

116

Aperture-priority mode allows the depth of field to be adapted to the subject. In this shot the background is blurred because of a wide aperture.

is best set via the film speed dial. A faster film speed produces less exposure, while selecting a slower speed than the film rating gives more exposure.

Aperture priority - the aperture determines the shot

The aperture-priority mode offered by OM cameras is based on pre-selection of the aperture, to obtain sufficient depth-of-field, leaving the shutter speed to be selected automatically. Even this automatic mode makes some elitist photographers turn up their noses because they want to decide what is happening personally. Such an attitude is, of course, nonsense. What happens with aperture-priority metering? As always, exposure metering determines the exposure value appropriate to the subject brightness and the film speed. Within a particular exposure value, one shutter speed goes with the preselected aperture, and this shutter speed is set by the camera. The elitist

photographer would set the same shutter speed in order to arrive at a correct exposure, but manually, and therefore more slowly than the automatic program.

If at any time you want to work with a certain shutter speed you can always use the MANUAL mode with match-needle metering. Alternatively, you could adjust the aperture with the camera at the eye-level, see which shutter speed is (likely) to be set, and adjust the aperture until the desired speed is indicated. A quick touch of the depth-of-field preview button will tell you whether the depth-of-field is still sufficient to give sufficient depth of sharpness.

It is also advisable to keep an eye on the shutter speed indication in the viewfinder when working with aperture-priority mode. This is because small apertures produce shutter speeds prone to camera shake, particularly in poor lighting conditions. If you rely on auto to select the correct exposure, without paying sufficient attention, it's easy to end up with well-exposed shots but blurred images sporting multiple edges. And should lighting conditions change drastically during the exposure, watching the viewfinder display doesn't help either, because the business of exposure control takes place autodynamically during the shutter release process.

Automatic program - to make things quick, or easy

Two OM cameras also offer the program metering system which continues to provoke heated debates amongst keen amateurs, despite being introduced into the top class models more than a dozen years ago. In fact, program was introduced in 1978 for the first time in the Canon A-1

What's so awful about program metering? It sets both shutter speed and aperture and, according to its opponents, restricts creativity. This is true if you consider creativity as manually turning the aperture and shutter speed rings. But even when the camera controls the shutter speed and aperture, it is still up to the photographer to see the shot and compose. Often nothing more is needed to gain good pictures because

The automatic program can be used if a certain shutter speed or a certain aperture are not essential for pictorial reasons.

there are surprisingly few subjects which need a specific shutter speed or aperture to be effective.

In such cases program quickly produces a correctly exposed shot. Exposure metering first determines which exposure value is correct for the shot and then mode selects the pre-programmed shutter speed/aperture combination.

Here are two examples. Based on a film of ISO 100/21° and the Zuiko 200mm,f/4 telephoto lens, the program of the OM-2Sp selects the combination 1/2sec at f/4 for EV5, and 1/1000sec at f/11 for EV17. As autodynamic exposure metering is also used in program, only the aperture is fixed. The viewfinder display shows the shutter speed that goes with the program. But this shutter speed is only used if the exposure metering process after the mirror has swung up does not yield a different result.

This has a great advantage for forgetful photographers. In order for the program mode to be able to use every aperture value on offer by the lens, the aperture ring has to be set to the smallest setting. If you forgot to do this, the iris diaphragm can only be closed as far as the value accidentally selected on the lens. But as the exact shutter speed is always determined during the exposure, a correct reading is almost always guaranteed. Over-exposure is threatened only if the fastest shutter speed, together with the accidentally selected aperture, is insufficient to cope with a very bright subject. But you will be warned in the viewfinder, so you can make the necessary adjustments.

Zuiko lenses – compact, light and good

However good a camera, however comprehensive its features, without a lens it is only a light-tight box for the film. Only the lens turns a camera body into a camera which the photographer can use to turn ideas into pictures. Olympus offers the OM owner quite a good range of high-quality lenses for capturing all kinds subjects, from the closest to the most distant.

Because of the photographic revolution currently taking place, triggered on one hand by the introduction of autofocus technology, and on the other by new camera designs, Olympus has introduced new concept cameras. These have futuristic bodies accommodating everything the average photographer needs, from the motordrive to flash and a built-in zoom.

A changing marketplace has led to a reduction in the availability of traditional Olympus SLR cameras. Now, in the early 1990's, only the OM-4 Ti Black is still being made but it is a topline camera aimed at keen amateurs and professionals. The range of lenses, too, has been affected by this trend. And like the OM-4 Ti Black, the lens range of the early 90's is targeted at photographers with high expectations. Many zooms popular with amateurs have been discontinued, while the range of fixed focal length lenses has only been trimmed slightly.

If you're looking for a lens to suit a secondhand OM camera, you don't have to choose from the current range of Olympus Zuiko lenses. You can always consider buying secondhand lenses, or quality optics from well-known and respected independent manufacturers.

As a result I won't introduce every lens in the Olympus range in detail, but will try to cover particular types of lenses. A 28mm,f/2.8 lens is an average wide-angle of modest speed, whether new or old, irrespective of its Olympus or Sigma title.

121

Consequently, it would be pointless to describe it in detail with a list of all its elements. To give you a rough idea of what you can expect from Olympus, I will cover the Zuiko lenses in the Olympus range during early 1991.

Before we get to the different lens groups, we need to cover two points. Firstly, is a zoom better or worse than a fixed focal length lens? Secondly, is a fast lens better or worse than a slow lens?

First comment: zooms or fixed focal lengths

Fixed focal length lenses have a certain focal length, are generally smaller and lighter than zooms and are usually faster. Their optical quality in borderline areas is generally better than that of zoom lenses which means that optical quality at the image edge and corners is slightly better. The bending of straight lines at the image edge (distortion) and the darkening in the image corners (vignetting) is also generally less pronounced. How much all this affects picture quality is a different matter entirely.

Zooms, on the other hand, have one great advantage: their focal length can be adjusted continuously, to allow very precise cropping before the shot is taken. Many modern zooms are also small and light (definitely much smaller and lighter than a collection of fixed focal lengths covering the same focal length range), and many offer such good optical quality that the shots are almost indistinguishable at a glance from fixed focal length shots.

Second comment: lens speed

Speed is the second term used to describe a lens. It is the widest aperture setting of the iris diaphragm. At all apertures, the lens speed is the ratio between the diameter of the entry pupil and the focal length. If the diameter of the entry pupil (which is the width of the 'aperture hole' as enlarged by the lens elements) is

half the focal length, the lens speed is $f/2$. If the diameter of the aperture hole is a quarter of the focal length, the lens speed is $f/4$. But an $f/4$ lens is not half as fast as an $f/2$ lens, it is one quarter as fast. This is because the mathematical calculation of the lens speed, and of every other aperture value, is based on the diameter of the entry pupil. On the other hand the entry pupil, through which light reaches the film, is a plane. And the area of this plane doubles in size when the diameter is increased by one quarter, and it quadruples when the diameter is doubled. This is why aperture of $f/8$ only allows half as much light to reach the film as aperture of $f/5.6$.

Whether a lens is termed fast or slow also depends on the focal length. A maximum of $f/2$ on a 50mm lens means the diameter of the entry pupil is 25mm, which is not difficult to achieve. A 50mm,$f/2$ lens is therefore classed as an average speed lens. The same maximum aperture on a 250mm lens requires an entry pupil diameter of 125mm, which requires a correspondingly wide lens barrel and large elements. Such a lens is difficult to design and construct, so its speed is well above average for such lenses (usually around $f/4$ to $f/5.6$) and it is therefore classed as fast.

Fast lenses have advantages which show up clearly for manual focusing as the viewfinder image is brighter, and it is easier to distinguish between sharpness and unsharpness in dim light. In addition, wide apertures allow faster shutter speeds to be used in particular lighting conditions which means that a fast lens is easier to hand-hold. Shallow depth-of-field goes hand in hand with wide apertures, allowing subjects to be emphasised by selective focusing. It can be a disadvantage, though, if only a very small part of the overall subject is sharp and other, equally important areas fall out of focus.

Standard lenses - better than you'd think

Standard lenses of 50mm focal length seem threatened with extinction because zooms have taken over where they left off. Many amateurs welcome this because they consider a 50mm

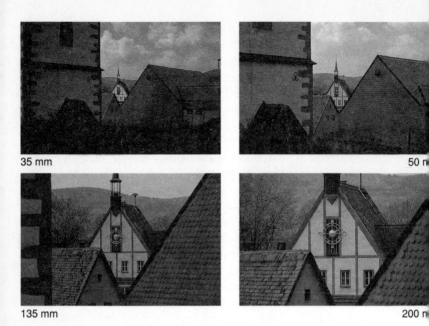

35 mm

50 mm

135 mm

200 mm

lens to be boring, a lens you can't do much with. But they over-look the fact that there can be boring photographers, but never a boring lens. A 50mm lens can, in fact, capture great shots with many subjects.

Snapshots and group shots can be easily achieved, and a 50mm lens is great if you want a neutral feel. Its angle of view is often claimed to match the angle of view of the human eye, which is not quite right because we use two eyes, but shots taken with the standard lens do seem natural and realistic. A contributory factor is that, when using a standard lens to shoot people or buildings, you generally work from shooting distances which give a perspective appearing neither steep, as with wide-angle lenses, nor flat, as with telephotos.

The Zuiko standard lens range includes one with a speed of f/1.8 which fulfils most requirements. But if your lenses are mainly of medium speed, because of cost, the f/1.4 standard is

100 mm

0 mm

This focal length sequence shows how the angle of view becomes smaller and the section of the subject larger as the focal length increases.

an affordable way of gaining useful speed for available light. And if the very compact 50mm,f/1.8 lens is too big for you, you might prefer the 40mm,f/2. 40mm is also a good compromise between 50mm and 35mm focal lengths.

Wide-angle - always a little more in shot

All lenses with a shorter focal length than the standard are generally considered wide-angles down to a focal length of around 24mm. Shorter focal lengths are super wide-angle lenses, with fish-eyes offering a shorter focal length still.

35mm lenses...
...made their name as the standard equipment of compact cameras and changed our viewing habits. Many people now

A 35mm wide-angle lens can be considered a "standard lens with extended angle of view".

consider them as standard lenses with merely an extended angle of view. The Olympus range includes the fast Zuiko 35mm,f/2, the Zuiko 35mm,f/2.8 as a lighter and cheaper option, plus a special lens - the Zuiko Shift - also with a speed of f/2.8. The 35mm focal length is the initial focal length of the 35-70mm,f/3.5-4.5 zoom, too.

Like the 50mm, 35mm lenses are well-suited to all kinds of subjects. The architectural photographer can squeeze in a building, without pronounced converging verticals in the shot. Groups are easily achieved with the 35mm lens. And for snapshots you can make full use of the depth-of-field available and possibly do without focusing altogether. Other uses of a 35mm lens include landscapes, overviews and interior shots. Don't forget flash photography either - most flash units can evenly cover the angle of view of a 35mm lens without accessories.

28mm lenses...

...increasingly play the part of the all-round wide-angle lens. Their 74° angle of view is just right for getting the whole subject in at a close distance, for squeezing in large views, or for gaining an impression of depth by using its steep wide-angle perspective.

Just like 35mm lenses, you can choose between speeds of f/2 and or f/2.8 for your OM camera. With this focal length the depth-of-field of the faster lens is not substantially reduced, so

126

28mm wide-angle lenses get a lot in the shot and are useful in small interiors.

a brighter viewfinder image and better low light shots are strong arguments for choosing the Zuiko 28mm,f/2.

These days 28mm lenses are no longer the first choice for group shots or snapshots. You either have to be quite a long way from the subject - which means that people will look very small - or reduce the shooting distance to get an acceptable image size. In this case you have to put up with the fact that the people towards the edges of the shot will be distorted - often not very popular.

24mm lenses...

...are a borderline case. They used to be considered super wide-angle lenses that were difficult to master and so demanded a lot of skill from the photographer. Nowadays many wide-angle enthusiasts have long switched to 21mm, or even shorter focal length lenses. The 24mm lens with its 84° angle of view can be a little problematic. Frame-filling architectural shots can be taken at closer range than with a 28mm or 35mm lens - but the converging lines can become very obvious. If shooting distance is increased and the camera held straight, the foreground tends to intrude much more than with longer wide-angles. On landscape shots the sky often dominates, which doesn't always improve the composition and may make exposure metering difficult. However, spot metering and ESP are proven remedies for such exposure problems.

127

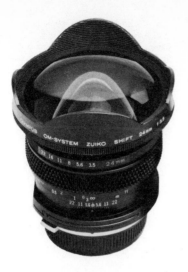

The Zuiko Shift, which can be moved laterally from the optical axis, is a special variant of a 24mm lens.

Despite all this it is hard to imagine a good photographic outfit without a 24mm lens. It allows magnificent panorama shots, and its steep perspective conveys the impression of enormous spatial depth. Effect shots, too, are possible with a 24mm lens. Portrait shots at very close range will show a large head with a large nose but quite small ears. If you approach people from near ground level, they will have long, long legs and large feet.

The Zuiko 24mm,f/3.5 Shift occupies a special position in this range. It has all the advantages of the normal 24mm lens, but without its disadvantages for architecture.

The short focal length manages to get a lot of the narrow lane in the view.

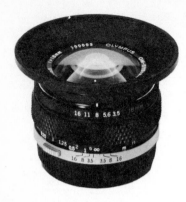

The 18mm super wide-angle lens is compact and handy; it can produce huge surprises in landscape photogrpahy and can turn a small room into a large hall.

Super wide-angle - great fun, but tricky

Lenses with even shorter focal lengths are quite clearly super wide-angle lenses. Finding suitable subjects is not always easy and you need to use careful judgment if the shots are to look good.

Olympus covers the super wide-angle option with two focal lengths, 21mm (with speeds of f/2 and f/3.5) and 18mm (f/3.5). The 18mm is very compact but has a protruding front element which needs to be protected by a special lens cap. In fact the front elements of all lenses should be protected by a lens cap. Scratches - even though quite rare - dust and finger-prints have quite a detrimental effect on image quality. Fortunately, dust and fingerprints can be removed with a blower brush and a few sheets of lens tissue, and if necessary, you can use small amounts of liquid lens cleaner.

Down by the sea or in the narrow lanes of an old town centre are all ideal places to use a super wide-angle lens. If a 24mm lens suffers from over-large skies or intrusive foregrounds, then it's even more true with wider angled lenses. They make great demands on the photographer, who needs to have a good eye for composition, as well as a sufficient imagination to find ways of effectively filling the foreground.

130

Fish-eyes - to round things off

Although barrel-distortion is an optical fault eradicated from most lenses using a suitable optical correction, it's not just overlooked on fish-eyes, it's even praised!

Here you'll get the pronounced curving of straight lines towards the image edge and it is only the lines which run through the centre which remain unaffected.

Apart from curving lines, fish-eyes are characterised by something else. There's the extremely wide 180° angle of view offered by the full-frame Zuiko 16mm,f/3.5, and the Zuiko 8mm,f/2.8 captures a huge angle of view in all directions to produce a circular image with a diameter of around 23mm in the centre frame. The 8mm lens captures everything right up to the edge of its front element, perhaps even the photographer's feet or tripod!

Fish-eyes are special lenses which were developed for special tasks but they can't be used very often in general photography because you soon get jaded with their effect and there are few subjects which really suit them. Theoretically every subject can be captured on film with a fish-eye - but the barrel-shaped distortion in itself doesn't guarantee a good shot. Landscapes under a cloudy sky, tight interiors, abstract structures in nature, or cars from the worm's eye view can be discovered with a fish-eye.

You should practise restraint and self-criticism when using such lenses so that your slide show has only a few successful fish-eye highlights.

Telephoto - getting close from a distance

All lenses with a focal length above 50mm are now called telephoto lenses, and with most this is true. Technically speaking the length of the lens has to be shorter than the focal length in order for the term to be used correctly.

For the sake of clarity, telephoto lenses can be divided into groups: **portrait telephoto lenses** with focal lengths between 70mm and 135mm, **long telephoto lenses** with focal lengths up to 300mm, and finally **super telephoto lenses** with focal lengths up to 1000mm.

Portrait telephoto lenses...

...are known by this name because a focal length of around 90mm can produce very pleasing portraits and half-figure shots. The shooting distance is not so small that it is unpleasant, but on the other hand, it is not large enough to make the face appear flat. By using wide apertures the depth-of-field is shallow enough to make the subject stand out from a background which fades into unsharpness. This helps to give a pleasing three-dimensional effect. But the name shouldn't prevent anyone from using such lenses for landscape and nature photography. They allow areas to be separated from the overall shot, with the tighter angle of view and the shallow depth-of-field contributing to the effect.

The Zuiko 100mm,f/2, a medium telephoto focal length, is an excellent portrait lens.

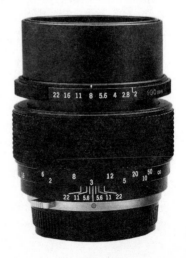

The Zuiko 85mm,f/2 and 100mm,/f2 lenses are very good typical examples of this type, and the 90mm,f/2 macro lens which also fits into this group has an extra feature up its sleeve.

Although 135mm lenses are generally deemed a little too long for portraits, they are not completely unsuitable. The classic 135mm lens is no longer available as a fixed focal length from Olympus - but you may be able to get a 135mm,f/3.5 or a 135mm,f/2.8 secondhand. Instead, the 65-200mm,f/4 and 50-250mm,f/5 tele zooms include this focal length in their range as does the discontinued 70-150mm,f/4. The 135mm focal length setting is also ideal for photojournalism and snap-shots.

The tight 18° angle of view cuts out distracting details, and with a wide aperture the shallow depth-of-field separates the subject from its background.

Long telephoto lenses...
...from Olympus include the 180mm, a now rare fixed focal length, and the 350mm, also not widely available. These lenses are not only good for making subjects you can't get close to fill the frame. If you're not afraid to get as close as possible to the subject, you will get a whole new perspective leading to inter-esting pictures. Other lenses can be used for this purpose, but long Zuiko telephoto lenses in the middle distance range can also be used to separate the main subject from its surround-ings. Many glamour and fashion photographers use this technique to get a stronger impression of their models.

Long focal length lenses, such as the Zuiko 180mm,f/2, 180mm,f/2.8, 200mm,f/4, 250mm,f/2, 300mm,f/4.5 or 350mm,f/2.8, are ideal for shots of sporting events or animals. But the steeper perspective obtained is also good for enhancing subjects and for seeming to move distant components closer together.

Super telephoto lenses...
...are not the sort of lens you'll need every day. On the con-trary, the Zuiko lenses with focal lengths of 400mm,f/6.3, 500mm,f/8, 600mm,f/6.5 and 1000mm,f/11 could just as easily

An example of a
vanishing species: a
fast 180mm lens.

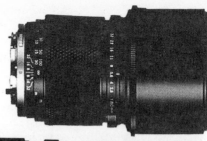

The Zuiko 200mm,f/4 is an almost "classic" telephoto lens, providing a
practical compromise in terms of focal length and speed.

This comparison shows what super telephoto lenses can deliver - the shot on
the right was taken with a 35mm lens, that above with a 500mm mirror lens.

be classed as specialist lenses. Super telephoto lenses are useful for tight shots of sporting action in the centre of the pitch. In fact the conflict between two football stars or the concentration of a baseball player can only be captured with such lenses. They are required to record detailed shots of wild animals from the safety of the safari. With such lenses you're well-equipped for landscape shots when the green hills of Africa are your subject, or when you're lying on the beach and want to take that shot of the sun as a large ball sinking over the horizon. A 400mm lens with a 2x converter will reproduce the sun at a size of 8mm on the film. That's a quarter of the image height when you crop in landscape fashion.

Specialist lenses - close-in and perfectly parallel

The Olympus program includes several lenses designed especially to solve particular problems. They can also be used normally according to their focal length as wide-angle, standard or portrait lenses, but are too expensive just to be used for this purpose. So if you're not a lover of macro or architectural photography, you should look towards more standard lenses to avoid spending money on something you don't need.

Macro lenses...

...extend the focusing range of your OM cameras right down close to the lens' front element. The camera gets very close to the subject and records it at a large image size. The Zuiko 50mm,f/2, 50mm,f/3.5 and 90mm,f/2 macro lenses are geared for magnifications of 1:2 (reproduction at half the actual size). With an extension tube the range can be extended to 1:1 (reproduction at actual size, with the subject the same size as the film format), but infinity focusing is no longer possible.

Many photographers find macro photography so fascinating that it often becomes a hobby within a hobby. Small subjects can be found everywhere in nature as well as in everyday life. You can start with rare coins, move on to the printed circuits in electronic equipment.

Lighting is usually a more difficult business than it is with traditional subjects because of the small shooting distance, but Olympus offers help in this area. Thankfully, the reflector of the T32 flash unit can also be tilted downwards, and if this isn't enough, the system includes special ring and macro flash units.

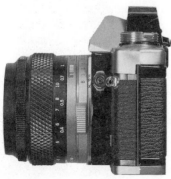

The 50mm macro lens set to infinity and to its largest reproduction ratio 1:2. The 50mm macro is an ideal standard lens for people who like to see their subjects at close range.

Macro lens heads...

... are also intended for shots at closest range. They often don't have a helicoid for focusing and can only produce images on film with a macro tube or with a bellows unit. Four such heads are available: a 20mm,f/2, and a 38mm,f/2.8 for extreme reproduction ratios beyond 1:1, plus a 80mm,f/4 and a 135mm,f/4.5.

Shift lenses...

...are a must if you spend a lot of time photographing objects in a small studio, or are keen on architecture.

The reason they are handy is such lenses can be shifted from the optical axis upwards, downwards, to the left and to the right. Shifting upwards on an architecture shot ensures that you get the whole building in the shot, without pointing the camera upwards, which prevents converging verticals. The alignment of the camera becomes easier and more precise if the camera is fitted with a Checker/Matte screen (focusing screen 10) for such shots and fitting a small spirit level in the hot shoe

of the camera also helps. Shifting the lens sideways allows you to push distracting elements out of the shot without changing your shooting position. By combining both movements in the studio you can photograph a subject like a box so that the front, one side and the lid are visible at the same time, while all the angles at the front remain right angle perpendicular. Another use of shift lenses is to take two shots, one after the other, with a shift to the right and a shift to the left. The two resulting slides can then be used to form a stereo image in a suitable viewer or can be enlarged and overlapped to form a panorama.

Two Zuiko such shift lenses are available. However, if your budget is limited, the 24mm,f/3.5 is perhaps out of the question. The 35mm,f/2.8 is by no means inferior, it's just that the wider 84° angle of view of the 24mm optic opens up more scope for the wide-angle fan - but it is still great to tackle beautiful buildings with such a lens. Exposure control is no problem if you rely on the automatic ADM exposure control of an OM camera. Simply focus with the aperture open, select a suitable

The shot with the 35mm lens not shifted and the camera held horizontally contains a lot of distracting foreground and only part of the tower. The unshifted 35mm lens with the camera pointing upwards does capture all of the tower, but it no longer appears as imposing as in reality. Shifting the lens upwards finally manages to reproduce the tower as it is supposed to be, making most of the foreground disappear.

139

lens shift, release the shutter and the exposure metering process at the film plane delivers the correct exposure. When working with match-needle or spot metering, you need to set the aperture and shutter speed before shifting to avoid metering errors. But this is no hassle because working with a shift lens is always a fairly leisurely business. The multi spot metering system of the OM-3 and OM-4 is very useful here and can produce remarkable results.

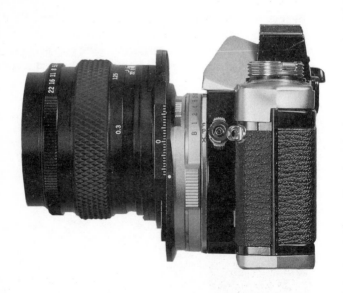

The Zuiko 35mm,f/2.8 Shift has a smaller angle of view than the 24mm Shift, but it is less expensive. It can be moved off axis relative to the film gate - here shown shifted up by the full 12mm - in order to avoid converging lines.

But before you consider buying a shift lens it's as well to know the shift range. The 24mm Zuiko can be shifted up and down by 10mm respectively, and moved left and right by 8mm. The 35mm lens offers slightly more movement: 12mm upwards, 13mm downwards and 10.4mm to the left and right .

Converters - the easy pathway to telephotography

Converters aren't lenses because they can't create an image on the film by themselves. A converter fits between the camera and the lens, and as it extends focal length it reduces speed. A 2x converter doubles the focal length but gives a speed loss of two stops. The speed is reduced by only one stop with a 1.4x converter which increases focal length 1.4 times.

Olympus converters are recommended for use only with certain lenses. When these limitations are observed the results are very good. For example, 180mm,f/2.8 with the 1.4x converter gives a 250mm,f/4 lens - very useful indeed.

Non-Olympus converters should be stopped well down to ensure reasonable quality reproduction.

Tele converters increase the focal length, this one 1.4x. The increase in focal length is accompanied by a loss in speed of one aperture stop.

Different brand lenses - worthwhile or not?

The Olympus lens range has been rationalised in recent years and this has particularly affected zoom lenses, which have many advantages. There's no lack of fixed focal length lenses available for the OM range of cameras, but as quite a few of these lenses are almost painfully expensive, it's well worth looking at what other manufacturers have to offer.

However, Olympus warns against using other manufacturers' lenses as these might not be geared as well as Zuiko lenses to the aperture control system of the camera. Any damage that results from their use will not be covered by the warranty and repairs can be very expensive. Do check with your photo dealer who will be pleased to discuss suitable lenses.

Features of the Olympus lenses
- keep a look out for them

A depth-of-field preview button...
...is featured on all Zuiko lenses with the exception of the reflex lens, where stopping down isn't feasible. The depth-of-field preview button is located on the rear chrome ring, opposite the lens release button. If you press the depth-of-field preview button the iris diaphragm closes to the preselected aperture. You can assess the depth-of-field in the now darkened viewfinder, as long as the iris diaphragm is not closed beyond f/8 or f/11 because at f/16 or f/22 you will no longer be able to see much. Used in conjunction with program mode, the depth-of-field preview button always closes the iris diaphragm to the smallest aperture, which doesn't make much sense. But using the depth-of-field preview function doesn't make much sense in conjunction with quick-working program metering. Using match-needle metering and aperture priority are better suited for working in this painstaking way.

The aperture ring...
...is right at the front on most Olympus lenses, or at least towards the front of the lens barrel. If you use an Olympus OM next to functioning milestones of photographic technology, like the Canon AE-1 and the Minolta XD-7, you might find the positioning of the aperture ring irritating. But the positioning makes sense, because the manual shutter speed ring is positioned around the bayonet of OM cameras. The appropriate ring can be found without any danger of mixing them up and you can hold the camera with the right hand ready to shoot, while the left hand sets the shutter speed, aperture and focus.

The lens release button...
...is located at the top left-hand side of the rear chrome ring when the lens is attached to the camera. In order to remove the lens, you have to press the release button and turn the lens to the right by 70° (seen from above, in the shooting direction). You should be able to hear the release button click into place when mounting the lens.

The filter compartments...
...of the Zuiko 250mm,f/2 and 350mm,f/2.8 lenses allow you to work with filters with a diameter of 46mm. Filters which need to be attached in front of the lens would be prohibitively large and expensive.

The focusing knobs...
...are a special feature of the 600mm and 1000mm lenses and are located at the side of the lens. Focusing takes place by turning the knobs which move the elements in the lens using a rack-and-pinion drive system, rather than a conventional helicoid.

The light colour finish...
...featured by some of Olympus' telephoto and super telephoto lenses - including the extremely fast 180mm,f/2, 250mm,f/2

and 350mm,f/2.8 lenses - is intended to prevent them heating up excessively when exposed to the sun to avoid problems with precise focusing.

The tripod socket...
...in the tripod mount of fast telephoto and super telephoto lenses is located roughly below the centre of gravity of the lens. This is important for safe, balanced positioning on the tripod, and takes the strain away from the camera bayonet as well as its tripod socket.

Lens terminology

The perspective...
...doesn't really have anything to do with the lens. It depends on the shooting distance and whether you stand upright or squat down to gain a 'worm's eye view'. Changing the focal length doesn't change the perspective, but a single step to the left or right does.

However, the focal length does play a part in connection with the perspective. You move closer to a subject with a wide-angle lens, and you step back from it with a telephoto lens, so the focal length influences the perspective as result of your choice of shooting position.

A further factor is the fact that objects which are far apart seem to move closer together in a telephoto shot but appear to move further apart in a wide-angle shot. These effects are known as flat telephoto perspective and steep wide-angle perspective.

The depth-of-field...
...also depends on the lens. The shorter the focal length, the further the depth-of-field extends. In addition, depth-of-field is also influenced by the shooting distance and by the selected aperture. The depth-of-field increases with the shooting distance, and it is deeper with smaller apertures than with wider apertures. These separate factors can add up so that at a long

distance, a stopped-down wide-angle lens produces a huge depth-of-field which may extend from a few meters to infinity. But the factors can also cancel each other out. A telephoto lens, for example, can produce the same depth-of-field as a wide-angle lens, if it is used from a great distance and with the aperture stopped down further.

The depth-of-field scale...
...is easy to use. Aperture scales are shown as a mirror image to the left and right of an index on the lens. Wide apertures are closest to the index, and small apertures are further away. When you align the focused distance with this index, you can use two identical aperture values, for the f/number set, to read off the two distances which indicate how far the depth-of-field extends.

The snapshot setting...
...uses the large extension of the depth-of-field with short focal lengths and narrow apertures. Aperture and distance are preselected.

At a given focal length these two figures produce a depth-of-field zone whose near and far points can be read from the depth-of-field scale of the lens. If you then take a photograph of a subject which lies within this depth-of-field zone you can omit focusing altogether and so work as fast, or even faster, than a photographer with an AF camera.

It is important that the lens should have a depth-of-field scale, and this is the case on most fixed focal lengths.

If the camera has an aperture-priority program as well, it will always be ready to shoot. But releasing the shutter when the iris diaphragm is completely open and with the viewfinder image only partially sharp, takes some getting used to.

The mirror lenses...
...of which the Zuiko Reflex 500mm,f/8 is one, are constructed from glass elements and mirrors. Light is reflected twice in the lens, once from a ring-shaped mirror at the back and then to a circular mirror at the front surrounded by the ring-shaped

front element. The front element causes unsharp points of the subject to appear as unsharp rings rather than unsharp circles - particularly noticeable on bright points of the subject, like reflections on water. Because of their construction, reflex lenses can't be stopped down and so too much light can only be overcome by using neutral density filters. The ADM metering system of the OM automatic cameras makes using a mirror lens fast and safe.

Converging lines...
...are a manifestation of perspective and it's natural that parallel lines running away from an observer converge. The edges of a house are such parallel lines, and if you point the camera up to get everything in shot, these lines run away from the camera and converge. Since an SLR camera's viewfinder shows exactly what will appear in the final result, you can easily judge and respond to converging lines. You can move further away from the building, and take the picture at a longer focal length, or you can move closer still and perhaps even use a shorter focal length, to use the converging lines as a creative tool. Alternatively, you can use one of Olympus' two shift lenses.

A super-wide-angle lens captured the relief in the foreground as well as the church behind it. However, it was necessary to point the camera upwards, which produced the resulting converging lines.

Flash – Olympus takes a stride forward

Taking flash pictures using the guide number certainly is dead easy - you only have to know your tables or be able to work with a calculating disc. Using a computer flash isn't difficult either, if you are able to sort out the data from a calculating disc. But there are many hidden pitfalls in using either of these methods. Thanks are due to Olympus whose TTL flash metering and control system, now used by other camera manufacturers, has made flash really easy, fast and safe.

If you want to, or have to use an Olympus OM camera with flash, you have a choice of three standard Olympus flash units, the T20, the T32 and the T45. There are also two macro flash units, the T28 Twin and the T28 Single, and two ring flash units, the T10 and T8. The full synchro flash unit F280 can also be used but its special technology, allowing synchronisation with shutter speeds right up to 1/2000sec, is only of real benefit when used with the suitably equipped OM-4 Ti. The way in which flash light is controlled divides the six Olympus oldies featured in this book into two classes.

The OM-2, OM-2Sp, OM-4 and the OM-40 have TTL flash metering and control, whereas the OM-1, OM-3 and OM-10 only use computer flash technology. The automatic computer flash program is available on the first three cameras, but there's no good reason for doing without the superiority of TTL exposure technology.

TTL flash control - metering at the film plane

TTL flash control is a parallel development to the autodynamic metering control system first introduced on the OM-2. When a metering sensor, and the corresponding technology, is

available for metering the light reflected from the film plane, the flash light reflected from the film surface can also be metered. However, the control system needs to be very fast because powerful flash units used at short distances with the lens wide open, may require the flash light to be cut off after as little as 1/4000sec to prevent over-exposure.

The advantages of such sophisticated technology are obvious. The metering angle for flash now corresponds to the angle of view of the lens. The sensor of the flash unit can't see anything different from the camera which avoids errors.

TTL flash metering is a working aperture metering system. Regardless of which value the aperture of the lens is set to, light is measured as soon as it reaches the film plane. This means that theoretically every lens aperture can be used, which allows you to adjust the depth-of-field to suit the subject, even for flash shots.

You should carry a flash unit, even outside - not all subjects are in the sunlight.

Automatic computer flash - the second best path to well exposed flash shots

The computer flash is closer to a pocket calculator than a computer. But when the term computer came into use, nobody dreamt that huge electronic data processing machines would turn into portables, or that real computers would be found almost as frequently in a child's rooms as an office.

A sensor in the body of the computer flash unit intercepts and meters the light reflected by the subject. The flash exposure is terminated when sufficient light to expose the film has been reflected. Metering and exposure control take place inside the flash unit, with the camera only delivering the firing pulse.

The sensor of a computer flash unit can imitate several apertures and in fact, the physical size of the sensor window is usually varied. Depending on its features, the flash unit can meter the light at two or more apertures settings which change along with film speed. A computer flash aperture of $f/4$ at ISO 100/21° becomes $f/5.6$ with an ISO 200/24° film.

The computer flash aperture determined by the flash unit to give the correct exposure needs, of course, to be set on the lens, otherwise the exposure will be incorrect. But you can also use this to achieve special effects like fill-flash to brighten a backlit subject, without destroying the backlit effect.

First establish which computer flash aperture is needed to light the main subject correctly with the flash unit. Set an aperture on the lens one stop smaller than this value, and obtain the background exposure using only the shutter speed control - but this must not be faster than the sync speed! The background will now be lit correctly, the main subject will be darker by one stop, and the effect should be pleasing.

Detachable sensors also allow this type of flash exposure control for indirect and off-camera flash, and since they are placed in the flash shoe, close to the lens, the danger of incorrect exposure is not great.

Olympus T20 - the smallest in the group

The flash unit T20 is relatively small and compact, offers a metric guide number of 20 (at ISO 100/21°) and has a permanently integrated reflector. This isn't a disadvantage because the T20 can be attached to the camera with the TTL Auto Connector T20, or to the TTL Auto Cord socket, for bounce flash or indirect off-camera flash. The coverage angle corresponds to the angle of view of a 35mm wide-angle lens.

TTL operation is possible with cameras equipped with this facility, and automatic models switch to the sync speed automatically. But if the auto mode can use a faster speed, the T20 is not triggered.

Two apertures are available when the T20 is used with computer control, and the flash unit can also be used manually by calculating using the guide number.

Switching is done by means of the reversible plate at the back of the flash unit. TTL control operates when the blank side is visible while the other setting has a calculator panel for determining the correct computer flash aperture.

The T20 provides a ready light and correct flash exposure check in the viewfinders of suitably equipped cameras. Power is supplied by two standard alkaline 1.5V batteries but it can also be used with the Power Bounce Grip 2 if desired.

Olympus T32 - the all-round flash unit for amateurs and professionals

The T32 is a larger, more powerful model with more features than the T20.

It is a hot shoe flash unit, gets its power from four 1.5V batteries and offers a guide number 32 (at ISO 100/21°). The horizontal reflector covers the angle of view of a 28mm wide-angle lens and it can be tilted up by up to 90°, and down by

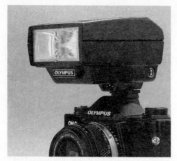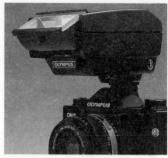

The T32 is a clip-on flash unit whose reflector can be tilted upwards for bounce flash, which produces a softer light.

The flash unit provides the correct amount of light, even if the room is no longer bright enough for a successful shot. TTL flash technology allows the depth-of-field to be kept shallow even for flash shots.

15°. The downward tilt is only possible after releasing a lock reached when the reflector is tilted upwards.

Direct connection to the TTL Auto Cord makes it easy to connect the T32 to the corresponding socket on the camera. This allows two flash units to be used, one on the hot shoe, one linked via the cord. Of course this is only convenient when the second flash is mounted on a grip, otherwise you'll be one hand short for working. The Power Bounce Grip 2 is an ideal

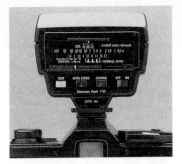

The reversible panel has a calculator on one side, for computer flash. It can also be switched to manual mode (guide number calculation) at full capacity (guide number 32) or 1/4 capacity (guide number 16).

grip, which accommodates the flash unit and houses four additional batteries.

The T32, too, is equipped with a reversible panel for selecting the flash mode. If the blank side is visible, the unit will use TTL flash metering with the OM-2 - fitted with an Accessory Shoe 3 - OM-2Sp, OM-4, and OM-40. If the panel is reversed the T32 can be used in automatic computer flash mode with three apertures. If you wish manual control is possible when it can be cut down from a guide number of 32 to 16, useful for lighting table-top subjects with several flash units. Switching to the sync speed takes place automatically with the relevant cameras, but again the flash is not triggered if the camera can achieve the correct exposure with a faster shutter speed.

A ready light and correct flash exposure indicators are provided in automatic computer and TTL mode if the camera is suitably equipped .

Olympus T45 - the light hammer

The T45 is a hammer head flash connected to a reversible camera grip. The flash unit can therefore be attached to the left or right-hand side of the camera. This makes handling the camera/flash combination easy for left-handed photographers if they use the camera with a winder or motordrive. In this case the shutter can be fired via a cable connection (M. Grip Cord 2) from the flash unit, held with the left hand, while the right carries out all adjustments on the lens.

For TTL flash operation the T45 is connected to the OM-4 and OM-2Sp by means of a TTL Auto Cord T2 (0.1m), which fits in a socket on the camera grip. If the camera is used with a motor-drive or winder, the connection is made via TTL Auto Cord T2 (0.15m). It can also be connected to the OM-1N and OM-2 N with the 0.3m TTL Auto Cord T, provided the camera has the Connector 4 in the hot shoe.

Apart from automatic TTL flash mode, automatic computer flash metering is also available. You can select three apertures - f/4, f/5.6 and f/8 at ISO 100/21°, and the flash is connected to the camera via a standard sync cord. If the flash is to be used manually, on a non-Olympus camera for example, the range runs from from f/45 to f/8. Like on the smaller flash units, switching between automatic TTL, computer flash or manual is accomplished via the reversible panel whose TTL side is blank and whose other side is equipped with an aperture calculator.

The flash head, with its permanently integrated reflector covering a 28mm wide-angle lens, can be turned and tilted to give indirect lighting.

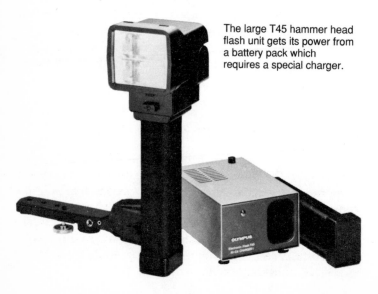

The large T45 hammer head flash unit gets its power from a battery pack which requires a special charger.

A rechargeable battery pack with charger is supplied with the flash unit and provides the necessary power for the T45. For studio use the T45 can also be connected directly to the mains using the AC Adapter 2.

The T45 activates the camera viewfinder display for ready light and correct flash exposure.

Ring flashes and macro flash - close-up lighting

Ring and macro flash units are specialist equipment for photographers who devoted their efforts to macro photography, or whose work involves the documentation of small objects with no shadows.

Ring and macro flash units comprise several components. The control component - the T Power Control 1 - is attached to the accessory shoe of the camera or connected to the PC synchro socket of the camera with the TTL Auto Cord T. The power source - a 6V battery case for four 1.5V U2 batteries - is placed

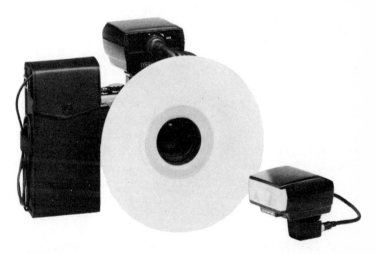

The T8 ring flash unit has interchangeable reflectors which cast soft indirect light onto the subject. A second flash unit (in this case a T20 is connected to the camera via a cable) can produce a more natural illumination of the subject.

elsewhere, and the flash is screwed into the filter thread of the lens.

The T Power Control 1 looks like the T32 flash unit, but instead of a reflector at the front, it has a connection for the separate flash heads.

TTL control is possible with the TTL-compatible cameras like the OM-2, OM-2Sp, OM-4 and OM-40. This is an invaluable advantage for macro shots because long extensions of macro lenses or bellows require complicated calculations or film-wasting test shots to gain the right exposure with traditional flash technology.

Automatic computer flash mode is not used at all for ring and macro flash units. The three reversible panels of the T Power Control 1 are designed only for TTL or manual control. One reversible panel is intended for shots with 50mm macro lenses, one for the 80mm lens head, and the third for working with the 135mm lens head. A reduction of the guide number is possible since a full capacity discharge could lead to over-exposed shots.

The T10 Ring Flash 1 (guide number 10) is equipped with a ring-shaped reflector for the flash and eight modelling lamps. The modelling lamps allow the lighting to be judged before the shot and because unwanted reflections can occur with shiny subjects, a unique polarising filter called the Ring Cross Filter POL is available.

Unlike the T10 Ring Flash 1, the T8 Ring Flash 2 does not aim directly at the subject. Instead, the flash is bounced off one of two reflector rings with a diameter of 15cm or 20cm. Here, too, the flash light comes from a ring-shaped reflector, and eight modelling lamps provide light before the exposure.

While the two ring flash units are designed for achieving shadow-free shots, often reducing the three-dimensional feel of the shot, the user of a T28 Macro Flash can play with light and shadow.

The T28 Macro Flash is available in two versions: with one reflector or with two. The reflector of the Single version can be attached to the T Power Control 1, in which case it lights

steeply from above. The two reflectors of the Twin version can be attached to the lens by means of an adaptor. Lighting can then be changed by rotating the reflectors around the optical axis of the lens, or by tilting the reflectors, or the single reflector. You will always be aware how light and shadow are influencing the shot because the rectangular reflectors of the T28, too, are equipped with integral modelling lamps.

Flash accessories - everything thought of

An accessory shoe...
...will be required if you are working with an OM-1, OM-1N, OM-2 or OM-2N and want to use flash. Accessory Shoe 1: for the OM-1, with direct contact point only. Accessory Shoe 2: for the OM-2 and the Quick Auto Flash 310. Accessory Shoe 3: for the OM-2 with direct contact point and flash coupling terminal to connect to the TTL circuit of T series flash units. Accessory Shoe 4: with direct contact point, contact for ready light and flash OK signals for the OM-1N and OM-2N, as well as flash coupling terminal for use of TTL mode with the OM-2N.

Accessory Shoe 4
for use with an
OM-1N or OM-2N.

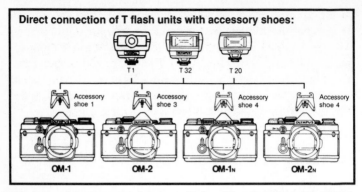

Direct connection of T flash units with accessory shoes:

This is how the accessory shoes go with the different models of the OM-1 and OM-2.

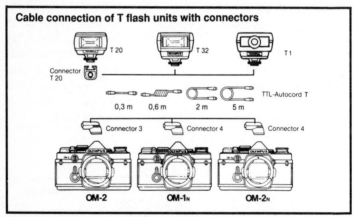

Cable connection of T flash units with connectors

The flash units can be used "on the leash" by screwing the connectors, rather than the accessory shoes, onto the cameras shown.

A flash connector...

...is required if you want to connect a flash unit to a camera without a connector socket via the TTL Auto Cord T. TTL Auto Connector Type 3 is available for the OM-2, and Type 4 for the OM-1N and OM-2N. Type 3 has the direct contact pin and flash coupling pin, while Type 4 also the signal contact (the flash coupling terminal does not, of course, function on the OM-1N).

The flash extender...

...increases the distance between camera and flash unit and therefore reduces the danger of 'red eye'. The contacts in the foot and in the shoe of the extender correspond to those of the Accessory Shoe 4.

TTL Auto Multi Connector 3X...

...allows three flash units to be connected to the camera to provide not only a higher light yield, but also more creative control over lighting quality. Furthermore, additional flash units may be added using Auto Cords and Multi Connectors. Up to nine flash units may be used.

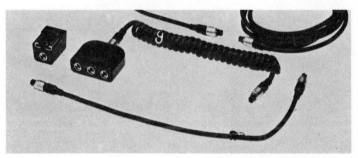

The TTL Auto Multi Connector 3X allows three flash units or three further 3X connectors to be attached, allowing TTL control of up to 9 flash units.

The Power Bounce Grip 2...

...is useful when you are working with the T20 or T32 and need faster recycling times. This is thanks to four 1.5V HP2 batteries supplying additional power located in the grip. Further advantages are that the flash can be angled for bounce flash with the T20 and T32, the grip is fitted with a shutter release button, and an OM camera with a winder or motor can be released with this button using the M.Grip Cord. When using the Power Bounce Grip 2 you don't, of course, have to do without TTL flash as long as you use a suitable cable. The contacts of the grip's hot shoe correspond to those of the Accessory Shoe 4.

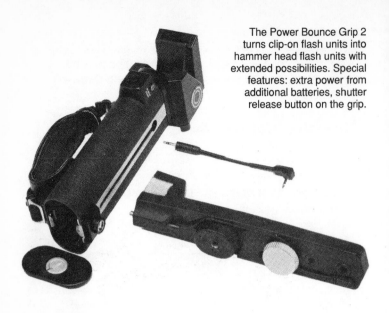

The Power Bounce Grip 2 turns clip-on flash units into hammer head flash units with extended possibilities. Special features: extra power from additional batteries, shutter release button on the grip.

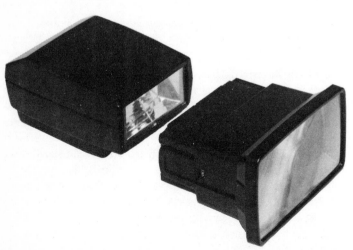

The flash zoom adapter allows the emission angle of the T32 to be adjusted to the angle of view of the lens.

The flash zoom adapter...

...narrows the light emission of the T32 and therefore increases light output. The adapter can be set to four positions so that the emission angle corresponds to the view of 50mm, 75mm, 100mm and 135mm lenses.

In addition Olympus does, of course, supply all the cords necessary to connect flash units, cameras and accessories.

Vivitar 283 - an alternative with automatic computer flash mode

Vivitar supplies a handy hot shoe flash unit - the Vivitar 283 with a guide number of 36 at ISO 100/21°. It has a bounce reflector and can be set to four computer flash apertures.

The sensor which captures and meters the flash emission is located in the unit but it can be removed and connected to the unit via a cord for more convenient and more reliable opera-

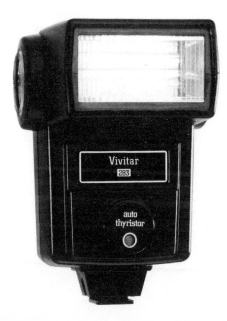

The Vivitar 238 is an oldie that is still available new. Its advantages: tilt reflector, high guide number (36), many useful accessories. One particular feature is the detachable sensor in case the camera does not yet make use of TTL technology.

tion with the flash off-camera. In this case, the sensor is attached to the accessory shoe of an OM camera while you hold the flash unit, or fit it to an ergonomically shaped bracket that can be fitted with a cable release. You hold the camera by the flash bracket, fire it from there, and still have one hand free to set aperture, shutter speed and focusing. If you are left-handed, the bracket can be swapped from the right to the left.

The calculator panel of the unit can be illuminated and the charge control indicator lights up when the unit is ready to fire but the capacitor is not yet fully charged. A beep tone announces when the capacitor has reached full charge. This means that you can keep power for the next flash which makes re-cycling very quick. After a correct exposure the OK signal on the flash unit lights up for just long enough to be seen with a quick glance out of the corner of the eye.

The accessory system already mentioned comprises diffuser disks for wide-angle shots down to 24mm, telephoto attachments which condense the light, and colour filters to provide coloured flash light. The battery adapters available take four 1.5V batteries, so when you're covering a wedding or other similar event, you can change the whole set of batteries in one go if necessary without losing a single shot.

Jargon - some explanations about flash units

Bounce flash...
...is a way of softening the harshness of flash light. Shadows are less distinct and the light more natural when it falls onto the subject after reflecting off a suitable area. Flash units with a bounce reflector are well suited for indirect flashing, and for shooting on colour slide film it is important for the reflective surface to be white, if colour casts are to be avoided. So when faced with wood-panelled ceilings or high ceilings a clip-on reflector, like those supplied by LumiQuest, can come to the rescue.

Off-camera flash...
...is necessary for lighting a subject from the side, or when you want to imitate morning sunlight with light falling from above, at an angle. In order to do this the flash unit has to be disconnected from the camera and coupled to the flash socket via a long sync cable. Calculations using the guide number must be adjusted to the actual distance between flash unit and subject. Computer flash control cannot be used in such cases, unless you work with an external sensor like the ones offered by the G series Canon Speedlites or models like the Vivitar 283.

The guide number...
...indicates the capacity of flash units and is based on a certain film speed (ISO 100/21°) and a set distance. The connection between the guide number, flash aperture and the distance is expressed in the guide number formula:

Flash aperture = guide number x distance.

To find out the maximum flash distance of a unit with a known guide number and with a particular aperture, you simply reverse the formula:

Distance = guide number x aperture.

Both formulae have to be taken with a pinch of salt because with interior shots in a large dark room, or outside at night, part of the light reflected by ceiling, walls, curtains and furniture gets lost. Therefore it's advisable to open the aperture by one stop, or avoid using the maximum distance calculated.

Red eye...
...occurs when flash light enters the eye through the pupil, reflects back off the red of the retina which is visible through the pupil. The risk of this happening is greatest in darkness, when the pupils are very dilated, and when the flash reflector

is close to the lens as on the T20 and T32. It's made worse at long distances where the light from the flash unit enters the eyes at an angle almost parallel to the optical axis of the lens.

The sync speed...
...on focal plane shutters is the speed at which the first shutter blind has completely cleared the film window before the second blind has started to run. Here the short burst of flash can fall onto the entire film surface. If the selected sync speed is too fast, the second shutter blind is already on its way when the flash fires, casting a shadow over part of the film.

Accessories – make more of your camera

Camera body, lens and flash unit are essential items of photographic equipment. Other items may not be necessary for successful shots, but they can make things easier and faster. And some shots can only be taken with the right accessory on the camera or the lens. Although Olympus offers a wide range of accessories, it's never a mistake to have a look at the range of other manufacturers - particularly if they are specialists.

Motordrives and winders speed up the film transport process; macro accessories discover subjects you may miss otherwise; and filters can produce shots which no longer bear much relation to the actual subject. Yet there are always friends and acquaintances who tell you that a real photographer doesn't need all that. They overlook the fact that using a winder to grab a quick second shot has never spoilt a picture, that the clearer colours produced by a polarising filter have never done any real harm, and that a shot whose effect is down to a creative filter is still better than no effect at all. In short, accessories are only as good, or as bad, as the photographer who uses them.

Motors and winders - better than their reputation

According to an unwritten rule, motorised film transport units fall into two groups - winders, which manage up to two frames per second, and motors, which can fire at up to five frames per second. In order to reach the maximum firing rate the shutter speed has to be right. If the shutter opens for 1/8sec for each shot, the film can hardly be moved on by five frames per second!

The OM Winder 2...

...is a handy piece of equipment with a round, sturdy grip on the right-hand side, and a shutter release set at the top of the grip. The mode selector can be found on its underside and this offers single and sequence mode as well as OFF positions. The winder is fitted with a remote control jack which makes sense, because only cameras which are automatically wound on after each shot can be used for 'unmanned' photography.

The winder screws into the tripod socket of the camera and is therefore fitted with its own tripod socket.

The winder is powered by four 1.5V batteries which are inserted into a holder and can therefore be changed easily. The battery holder is also available as a separate accessory, which lets you carry a spare in your gadget bag loaded with a fresh set of batteries. In the winter it is even more sensible to connect an external power source to the winder which can be kept warm in your coat pocket to avoid power loss caused by low temperatures.

The 6V Power Packs 1 and 2 are available as external power sources. The Power Pack 1 takes four 1.5V AA batteries (of the Kodak KAA-P type), the Power Pack 2 four 1.5V mono cells (of the Kodak KD type). Switching to a new power source is not necessary because as soon as the plug of the Power Pack is inserted into the external jack, the winder automatically switches to the external supply.

The OM Motor Drive 2...

...is a multi-component unit. In the centre is the actual motor, a fairly thin plate screwed directly into the camera. It is fitted with a handgrip at the front right-hand side, which sits well in the hand thanks to its moulded grip. The shutter release button is within easy reach of the index finger, at the top of this grip and an LCD panel is located at the back of the motor. This indicates the necessary actions to be carried out at any one time, as follows:

1. Open back cover
2. Load film
3. Close back cover (film wound to first frame)

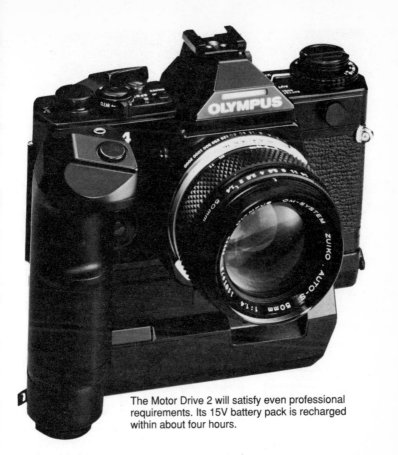

The Motor Drive 2 will satisfy even professional requirements. Its 15V battery pack is recharged within about four hours.

4. Exposures remaining indicator (film lengths can be input manually via the setting and reset buttons next to the LCD display window. Otherwise, the motor assumes a 36-exposure film is loaded)

5. Press rewind release button.

These five functions are carried out with the OM-1, OM-2, OM-2Sp, OM-3 and OM-40. The OM-10 can only be used with the winder.

Four further functions are exclusive to the OM-3 as well as OM-4:

6. Activate motorised rewind

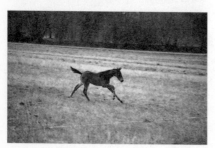

Motorised film transport facilitates sequences of shots such as this.

Film loading, step 1

Film loading, step 2

Film loading, step 3

Frame number display

Film rewind, step 1

Film rewind, step 2

Film rewind, step 3

Film removal, step 1

Film removal, step 2

The motor itself is small, it is the power supply components which make it fairly large and heavy. The LCD panel at the back shows the photographer what he needs to do at any one time.

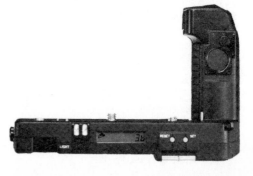

7. Film rewinding
8. Switch off motorised rewind
9. Open back cover, take out film.

As the controls are shown graphically, even a novice can use the motor for the first time and get everything right straight away.

The motordrive consumes a lot of power. Two different power sources can be attached to it. A 15V Control Pack, which is charged by a special charger in four hours, follows the shape of the motor and extends the handgrip. The mode selector for single, sequence and no film transport (OFF) mode is located at the bottom of the grip of the Control Pack. Single frame mode means that the motor stops after winding, sequence mode that one frame after the another is fired while the finger remains on the shutter release button.

A lockable second shutter release button is located at the back of the Control Pack and the thumb comes to rest on this on

vertical pictures. This may be a new shutter release experience, but it is far easier than reaching over the camera to the normal shutter release button. Incidentally, the shutter release of the camera is not locked when a winder or motordrive is attached but it only fires the shutter - it doesn't activate film winding. This takes place as soon as you press the motor's shutter release button, and the shutter is cocked simultaneously.

Instead of the Control Pack you can also attach the 18V Control Grip, which is designed as a handgrip. Its twelve 1.5V AA batteries do add weight, but thankfully the whole photographic unit sits well in the hand. The 18V Control Grip, too, has a shutter release which is large and easy to use even with gloves on. In addition, the grip also has a mode selector.

There is also the option of the 250 Film Back, which takes 10m of 35mm film. This length of film can only be used with motordrive or winder power.

So are motordrive and winder important for the amateur photographer? Are they sheer luxury? Or are they somewhere between those two extremes? The latter is the case.

Motorised film winding is, I feel, insurance against missed shots. You can miss shots because the film hasn't been wound on, or because somebody runs across at the crucial moment, because the subject has pulled a silly face, or because you didn't get the composition 100% right. The shot is usually saved if a winder or motordrive allows you to press the shutter release again, straight away. Motorised film transport is also very convenient for copying. Thanks to the force required to turn the film advance lever, the camera wanders slightly from its original position in tiny steps, and after a while you'll suddenly notice something at the edge of the frame that wasn't supposed to be visible. Moving the film advance lever also tends to be awkward when slide duplicating, where you've got enough to do placing the slides in the holder.

The Winder 2 will be sufficient for everyday photography. For a fast second shot, or long picture sequences with the repro unit or slide duplicator, its 2.5 frames per second is not necessary, but the single frame mode is handy. If you shoot much sports photography, or if you want to study animal movement,

the Motor Drive 2 should serve you well. The winders and motors are definitely not film wasting machines, as they were called when first launched for amateur cameras.

Viewfinder accessories - seeing better is judging better

The viewfinder system is the greatest advantage of SLR cameras compared to other 35mm models. The light falls from the lens onto the instant return mirror, from there it is reflected onto the five-sided pentaprism (penta - five in Greek), and from there reaches the viewfinder eyepiece. During this process the image, projected into the camera by the lens the wrong way around and upside down is also recorded by the film in this fashion, is turned the right way around and upright in the viewfinder. You can also see fairly precisely how the subject will appear in the final result. The qualifier 'fairly precisely' is necessary because the distribution of sharpness and unsharpness is not as easy to see on such a small viewfinder image as it is on the matte screen of a large-format camera, and because the image is trimmed slightly at the edges. The reason for this is that a small section of the image area is always lost when slides are framed. When you look at the unframed slide you will see a touch more than what appeared in the viewfinder. When you look at the framed slide, the picture and viewfinder image are more alike.

The focusing screen...
...is an important component of the viewfinder. The image redirected upwards by the mirror is projected onto the focusing screen, and it is this image that you see in the eyepiece.

You can judge quite well whether the image on the focusing screen is sharp or unsharp, but focusing aids do make exact focusing even easier.

The OM cameras come with focusing screen 1-13 as standard. This screen has a split-image rangefinder in the centre, surrounded by a microprism ring.

Focusing screens which are interchangeable by the photographer:

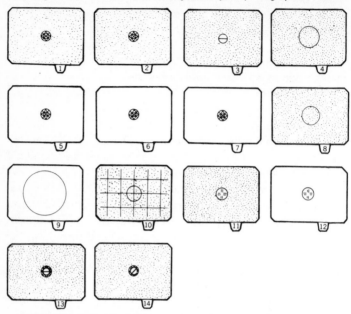

1-1. Microprism-matte (most lenses); 1-2. Microprism-matte (standard and tele lenses); 1-3. Split-image matte (most lenses); 1-4N. All matte (most lenses); 1-5. Microprism clear field (wide-angle and standard lenses); 1-6. Microprism clear field (standard and tele lenses); 1-7. Microprism clear field (super tele lenses); 1-8. All matte (super tele and astro telescopes); 1-9. (endoscopy); 1-10. Checker matte (shift lens); 1-11. Cross hairs matte (close-up and macro); 1-12. Cross hairs clear field (photomicrography and greater than life-size macrophotography); 1-13. Microprism/split-image matte (most lenses); 1-14. Microprism/split-image matte (most lenses).

The split-image rangefinder is set horizontally. When the subject is not exactly in focus, the rangefinder splits a part of the subject in half, and displaces the two portions away from each other. During focusing the halves move further apart or towards each other. Focusing is correct when the portions merge perfectly.

The split-image rangefinder works best when the subject has clear lines to adjust focus on. If this isn't the case, you use the

172

microprism area which causes unsharp parts of the subject to shimmer. The focus is correct when the subject appears smooth in the microprism ring. When you work with slower lenses, from about f/5.6 onwards, the two halves above and below the split-image rangefinder darken, and the microprism appears grainy. This effect can be avoided a little by centring your eye over the viewfinder eyepiece, but the only other way to avoid it is to change the focusing screen if you have a 'single-figure' OM camera. But it should also be pointed out that the only Zuiko lenses that slow are found in the super telephoto range.

Three focusing screens out of a total of 14 are particularly useful for everyday photography. Focusing screen 1-10 is a matte screen with a grid pattern engraved onto the screen which helps composition. This is particularly useful for architectural shots - especially with one of the Zuiko shift lenses.

Focusing screen 1-11 is a matte screen with central cross hairs makes focusing in the close-up and macro range easier. This screen is the right choice if you frequently use the extension tubes or auto bellows.

Focusing screen 1-14 is a matte screen with microprism ring and split-image rangefinder. This screen differs from the standard focusing screen in the 45° inclination of the split-image rangefinder. This focusing aid allows you to focus on vertical or horizontal lines in the subject.

Changing the focusing screens is no problem. They are supplied singly, with a special tool similar to a pair of tweezers. This allows the focusing screen to be gripped securely without touching the surface when fitting it through the lens mount of the camera.

The Varimagni Finder...
...is another very useful accessory. It is pushed into the groove in the frame set round the viewfinder eyepiece. This finder allows you to see around corners, so you can look into the viewfinder from above or, as the finder can be turned, from the side. You will come to appreciate this option when taking shots of plants near the ground, when you want to take tabletop shots and the tripod is only extended to table height, or when

your OM camera is attached to a repro stand because you want to duplicate your best slides with a slide duplicator. It provides a 1.2x magnification of the viewfinder image.

But the Varimagni Finder doesn't just make looking in the viewfinder more convenient, it also increases the focusing precision - when half a millimetre matters in the macro range, or when you are working with long telephoto lenses. If you push the lever on the side upwards, the centre of the focusing screen is magnified 2.5x, so you can distinguish between sharp and unsharp focus more clearly.

However, one advantage of the normal view of the matte screen is lost: the image in the Varimagni Finder is the wrong way around.

If you want the image the right way around with an angle viewfinder, you can use a device from Hama: the Prisma angle viewfinder gets the image 'around corners' the right way around - but without the magnification option. This is done by the Viewfinder Magnifier, also from Hama. The Viewfinder Magnifier has the advantage that it can be used when the camera is mounted on a tripod in the normal way, fitted with a long telephoto lens such as the 500mm Reflex, and when the viewfinder eyepiece is conveniently at eye height. In a situation like this an angle viewfinder tends to be impractical.

A Varimagni Finder is useful in difficult photographic situations. For example, when the subject is very close to the ground and you need to shoot it from the side, or when the camera is on a repro stand.

Macro - seeing everything close up

We have already encountered macro lenses and lens heads in earlier pages. Whereas the macro lenses open up the close-up range to their owners, the lens heads need to be connected to a focusing device because they can't get a picture onto the film by themselves. Two such devices are available, the Telescopic Auto Extension Tube - an Olympus speciality with a lot going for it - and the Auto Bellows. There are also several additional aids, but if you don't want to venture quite so deeply into macro photography, there is the Close-up Lens f=40cm.

The Close-up Lens f=40cm...

...is available in two sizes - for lenses with a 49mm filter thread diameter, the other for lenses with a 55mm thread diameter. If you are not yet quite sure which lenses will be added to your Olympus equipment, you should choose the larger close-up lens. It can still be attached to smaller lenses using a reduction ring but the smaller lens can never be attached to larger diameter lenses.

The close-up lens fools the prime lens to believe that the shooting distance is greater than it actually is. This means that the lens can be focused to close distances normally outside its range. In this way a 35mm wide-angle lens can take shots at magnification ratios up to 1:4, and the very handy Zuiko 100m,f/2 can reach 1:2.3 - almost half life size.

Like all other close-up lenses, the f=40cm has the advantage of being very light and of not affecting the speed of the lens.

Extension tubes...

...offer an easy path to close-ups - the set of three Olympus extension tubes weighs just 245g, but they are more fussy to handle than the close-up lens. They are attached between camera and lens which increases the lens extension, produces a larger magnification ratio but 'loses light'. This isn't a problem in terms of correct exposure, as all OM cameras offer TTL metering, if not ADM metering, both of which take the loss of light into account. But the viewfinder image darkens and shut-

ter speeds become slower. This is no different with the Telescopic Auto Extension Tube or the Auto Bellows, but extension tubes only allow a step-by-step approach into the close-up range, whereas the other two devices offer continuously variable magnification.

If you are still interested in extension tubes, they are 7mm, 14mm and 25mm long and can be put together in any combination you like and the aperture control system of the lens continues to operate, which allows open aperture metering up to the point of exposure. The 25mm extension tube can also be used on its own with the Zuiko 50mm,f/3.5 macro lens and increases its largest reproduction ratio from 1:2 to 1:1. A reproduction ratio of 1:1 means that a 24x36mm subject fills the frame of a 35mm negative or slide.

Note: the very early (1973) sets of extension tubes are non-automatic so if you are buying secondhand - be careful.

The Telescopic Auto Extension Tube 65-116...
...is basically also an extension tube - but with one difference. It compresses like a telescope, and so folded it is 65mm long and can be extended to a length of 116mm. You can also attach

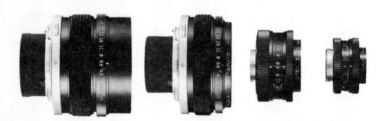

The Olympus lens heads.

A very special type of extension tube: the Telescopic Auto Extension Tube that can be continuously extended from 65mm to 116mm.

standard Zuiko lenses to the Telescopic Auto Extension Tube, but it is really a focusing device for using 20mm, 38mm, 80mm and 135mm lens heads. The maximum reproduction ratios achievable with the lens heads are engraved on the tube and magnification is preselected by the extension of the tube and focusing is carried out simply by changing the distance between subject and camera. As the tube is light and handy, this can easily be done with the camera hand-held. But it is always safer to work with a tripod and sensibly the Telescopic Auto Extension Tube is fitted with a detachable tripod mount.

As the addition "Auto" to the name suggests, the Telescopic Auto Extension Tube is designed to transfer aperture control data, so that you can always work with the iris diaphragm fully open.

The OM Auto Bellows...
...is quite a large unit. It has two types of mount connected by bellows and can be adjusted independently on the 23cm focusing rail. The length of the extension determines the magnification ratio, depending, of course, on which lens is attached. The front mount for the lens has a camera bayonet without an automatic diaphragm lever. This is replaced by a shutter release socket at the foot of the front mount which takes one end of a double cable release. The other end goes in the cable release thread of the camera and one touch is sufficient to stop down the aperture to the selected value and fire the shutter. This also works if you turn the front mount around so that the lens points with the rear element facing the subject. This retro position is important if you use the Auto Bellows with normal lenses not designed to work at such short distances. If you turn such a lens around, the rear element group - which is optimised for short distances - faces the subject which is, of course, close to the lens for macro shots. The front element group which is designed for longer distances now points towards the film plane, which is further away from the subject than on normal shots. Reversing the lens in this way is very effective with symmetrically constructed lenses like wide-

angles and standard lenses. But it is better to attach a lens head to the Auto Bellows.

Even if you don't have the double cable release, you can preselect your chosen aperture using a special lever on the front mount of the unit, just before exposure is made.

The rear mount is fitted with a lens bayonet. This is where the camera is attached - possible only when the mount is pushed almost all the way back.

The focusing rail itself can be moved forwards and backwards on a small platform to make focusing easier when the whole unit is tripod mounted.

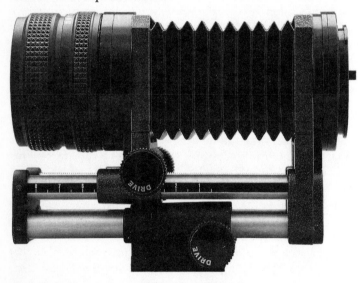

Databacks - bringing order into your life

The back covers of 'single figure' OM cameras can be taken off in one movement, and the corresponding databacks can be attached just as easily.

In terms of technology, the Recordata Back 2 and Recordata Back 4 models are generations apart. On the Recordata Back 2 the data imprinted into the film picture is preselected on four command dials as different combinations of letters - only as the first digit in the date line - and numbers. The years 78 to 98 are

available as two digits. The Recordata Back 4, on the other hand, is much more modern and you don't even need a calendar or a watch if you have a Recordata Back 4.

The following data can be imprinted: the date in three versions, date plus time, a fixed number and a number after which the camera advances automatically.

The Recordata Back 2 is connected to the camera by means of a cable, whereas the 4 is coupled directly with the camera via the contact underneath the transport spool in the camera.

How important are databacks?

That depends on the objective. Data imprinting is essential for the documentation, even if the imprint line at the lower right-hand side of the shot is intrusive.

For private photographs, too, data imprinting is not to be scorned, as it enables you to put photographs of children or holidays in the correct order later on. But it is advisable only to mark some shots - the first shot on a film or exposure sequence - as this allows others to be placed in the right context without being imprinted.

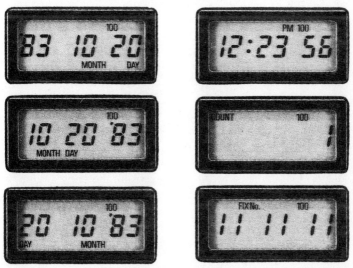

A databack is very useful for documentary photography. These include shots of children, as the date when they were taken can be documented for all time.

Filters - can turn dreams into reality, or simply make better shots

The rule that lenses should generally be protected by a UV or skylight filter doesn't always apply. A filter provides effective physical protection in hostile conditions, like at the beach, in a snowstorm or when it rains. When the light does contain a high proportion of UV, the relevant filters are indispensable for successful shots in the mountains for example and more recently, in places like Australia where the hole in the ozone layer has noticeable effects. But when these conditions are not present, you should not put a filter in front of the lens because the additional glass or plastic was not taken into account in the lens design and can therefore lead to poorer image quality due to added reflections and a reduction in contrast because of flare.

UV filters (which should really be called UV-block filters) and skylight filters fall into the group that can be used to improve the colour reproduction by preventing a slightly blue cast caused by too much ultraviolet light.

Polarising filters and one-colour filters for black-and-white shots fall into the same filter group.

The polarising filter is important for eradicating reflections from non-metallic surfaces. It increases the transparency of glass and water, and reproduces the colours of other surfaces more richly. However, this doesn't always work equally well - the angle between the sun and the optical axis of the lens should be around 90° for the optimum effect. This is why you need to judge the effect in the viewfinder of the SLR camera. Buying a so-called circular polarising filter is definitely the best idea for OM cameras because the exposure metering system of all cameras with a semi-silvered mirror is adversely affected by linear-polarised light entering the camera. This is not important on the OM-1 and OM-2, but if you also have an OM-3, OM-4, OM-40 or OM-2Sp, you can use the circular polarising filter for all cameras. Incidentally, original Olympus polarising filters are supplied in special thin mounts which prevent vignetting (corner cut-off) when using wide-angle lenses.

A polarising filter removes reflections from the lacquered surface.

On black-and-white shots the one-colour filters provide a better distinction of the subject colours through differentiated grey tones. The most widely used is the yellow filter which makes the blue of the sky appear darker and so intensifies the distinction between clouds and sky in a black-and-white shot.

Neutral density filters, too, help to improve a shot. Such filters can help if high contrast between bright sky and shadowy landscape prevent an effective shot. The dark side of the filter reduces the bright light of the sky by one or two exposure stops, thereby reducing the contrast sufficiently for the film to cope and produce a correctly exposed result.

You should have such filters for all lenses in your equipment, but as not all Zuiko lenses have the same thread diameter, the purchase of screw-on filters can become expensive.

Some problems can, of course, be solved with step-down rings, but the filters systems, such as those offered by Cokin are better still. At the heart of the Cokin filter system is an adaptor which can be attached to lenses with different diameters via adaptor rings. It is advisable to attach adaptors - which aren't expensive - to all lenses. The A-adaptor for filter threads between 36mm and 62mm is usually sufficient for the small Olympus Zuiko lenses but if you have larger lenses, or super wide-angle lenses from 24mm onwards, and want to use filters, you should go for the larger P system adaptor. Every Cokin A-filter can be inserted into every Cokin A-adaptor, and the same goes for every P-filter and P-adaptor - and it's no great effort. The filter is simply inserted into one of the guide slots of the adaptor. This is a great advantage if you frequently work

Creative filters, such as the Cokin multiprism or the speed filter from the same company, can produce several versions of the subject in the shot or give an impression of movement that was not actually in the subject.

with creative filters, and several dozen are included in the Cokin range.

For a full description of all Cokin filters and how to use them see *Cokin Filter System for Photo and Video* by Heiner Henninges (Hove Foto Books, 1990).

Tripods - because camera shake is out

If you blow up a shot sufficiently, you will notice that even 1/125sec wasn't fast enough to keep the 85mm lens steady. But with average enlargements you can assume that the following rule of thumb is correct:

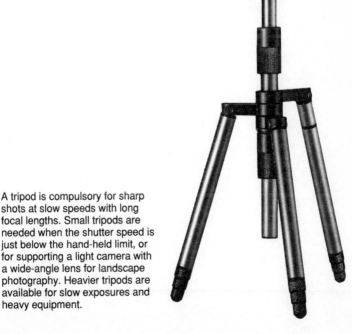

A tripod is compulsory for sharp shots at slow speeds with long focal lengths. Small tripods are needed when the shutter speed is just below the hand-held limit, or for supporting a light camera with a wide-angle lens for landscape photography. Heavier tripods are available for slow exposures and heavy equipment.

Slowest shutter speed for hand-held shots = 1/focal length.

If the shutter speed reaches this figure or is slightly below it - 1/125sec for a focal length of 210mm, for example - it's time to rest the camera on something or use a small tripod.

Heavier, larger tripods are required for very slow shutter speeds, or for tripod shots with the Olympus OM-3, the Motor Drive 2 and the Zuiko 250mm,f/2. Fitting the right head to a tripod is as important as the tripod itself. Ball heads gives the greatest possible freedom of movement, allowing the camera to be tilted in all directions.

A small spirit level in the accessory shoe helps to align the camera precisely.

Bags - portable solutions

In order to transport your entire photographic outfit, including those Cokin filters stored in small plastic boxes, you need to get a bag. There are countless types of photo bags, but they are not all the same so take your time when buying - if possible take your equipment to the shop to try it for size.

Films – they capture what the camera sees

Olympus, too, is involved in the development of cameras that can get by without films. But the electronic recording of images in the early 1990's is not as advanced as was predicted in the early 1980's. At that time Sony was surging ahead with the Mavica, and many photographers worried about the future of the silver halide film. In fact, it has been developed and improved since then. Fast and super-fast films are now available, resolving more detail than ever, and colour rendering leaves nothing to be desired. And with an Olympus from yesterday you can enjoy all this progress today.

Cameras, lenses and flash units are the essentials of photographic equipment, but without films they are dead machines. The range of films has never been as attractive as it is today but this is precisely why many amateurs wonder which type of photography to go for. The selection of a film always determines the processing method adopted after the shots have been taken.

Black-and-white films - still getting better

Black-and-white is in again, particularly among young photographers seeking the origins of photography. However, black-and-white photography means processing in your own darkroom because all commercial labs are geared to processing colour films.

Modern black-and-white films, such as the Kodak T-Max series, have reached a level of quality that seems almost incapable of further improvement - but further improvements are sure to be made. Fine grain and sharpness have made it possible to record even the finest detail. ISO 100 films in particular

now show hardly any grain even on poster-size enlargements, and faster films like the T-Max 400 or T-Max P3200 (which can be exposed at ISO 400/27° as well as ISO 6400/39°) produce far better results than would have been dreamt possible even just a few years ago.

ISO 400 black-and-white films are so good these days that many photographers use them as all-round films, loading an ISO 100 film only when they are taking shots of subjects with fine detail like macro shots.

But in order to get pictures with clear, bright shadows, it is advisable to over-expose black-and-white slightly, and then to develop it less. This is easily done on manual cameras like the OM-1 and OM-3, while the OM-3 offers the added advantage of spot metering.

It is therefore better to aim the camera at a darker part of the subject when metering black-and-white shots.

You will find out during your first darkroom session how your favourite film needs to be developed to produce suitable negatives.

Colour negative films - the all-round material capable of more

Colour negative films are the most widely available and used photographic material, but different colour negative films are not equally suitable for every subject.

Go for a 'normal' film like Kodacolor Gold if you tend to want to enlarge the whole negative up to 40x50cm to go in the album or on the wall, and if you're one of those photographers who sometimes leave a film in the camera for a long period of time - perhaps for a whole summer. Such films are tolerant materials in terms of exposure latitude. When using an SLR camera with TTL metering which may even meter the exposure during the shutter release process, the exposure tolerance of a film is not as important as on compact cameras. But if you're approaching the hand-held limit with your OM camera, and haven't got a tripod with you or anything to rest the camera on,

you can easily under-expose a colour negative film by two stops and the prints will still be good quality.

As such films are considered all-round materials which are used in simple compact cameras, as well as top-quality SLR cameras, their speeds are graded so all cameras can cope with them.

An ISO 100 film like the Kodacolor Gold 100 is the film for all occasions - from macro shots and portraits to architectural shots and landscapes.

An ISO 200 film is ideally suited for landscapes, snapshots and portraits inside, and this film can be considered as a standard if you frequently use slow zooms, like the excellent Zuiko 75-150mm,f/4.

An ISO 400 film used in this situation and in the same light conditions produces a shutter speed one stop faster, but it shouldn't be used as a film for every occasion. Hand-held shots in low light outside at dusk or for interiors maybe, or flash shots where the large range of a unit is important, are the domain of a Kodak Gold 400 film. If you're looking for poster-size enlargements - perhaps from just a part of the negative - or when you want to shoot very fine detail, high performance colour negative films like those in the Kodak Ektar series are the right choice. Although these films have much to offer, they also demand a lot from the photographer.

The Ektar 25 is the slowest film and is right for all shots where high resolution, biting sharpness and fine grain are important. The negatives can be enlarged to poster size without the grain becoming visible and the exposure metering of every OM camera covered in this book can be used with the ISO 25 film. A setting of ISO 125/22° isn't a problem, either, so you can easily take shots with the Ektar 100 - a top quality all-round film. In terms of fine grain it doesn't quite measure up to the Ektar 25, but the small difference gives a considerable improvement in speed. The Ektar 1000 at ISO 1000/31° is intended for situations where there's very little light but offers remarkably good grain even in critical situations, renders shadow details well and manages to give good colour reproduction even in mixed lighting (daylight with artificial light).

In order to use the advantages of these films you have to do your bit as the photographer. Stop down even good lenses by one or two stops to achieve the best quality, meter the exposure very precisely, which is easily possible with the OM-3, OM-2Sp and OM-4 models, thanks to their spot metering system. Also bear in mind it is never wrong to connect the camera to a tripod in to eliminate any risk of camera shake.

Colour slide films - glowing splendour

Apart from one exception, it is possible to develop slide films at home, but there is not much point to it. It is best to send Ektachrome film to a commercial laboratory, or to have it developed by one of the E-6 labs found in many large and medium-sized towns. The developing process takes less than two hours, so you will soon get your slides ready for framing on the lightbox.

The exception mentioned above are Kodachrome films which have to be developed by the Kodak laboratory. This is necessitated by the special make-up of the Kodachrome films which in fact start off as black-and-white films. Although the colour data is stored during the exposure in different layers sensitised to the three primary colours, colour pigments are only inserted into the layers during processing. This is why Kodachrome films are thin and have only minimal grain and stand out in their speed class - ISO 25/25°, ISO 64/19° and ISO 200/24° - as very high sharp and full of detail. In a direct comparison between the Kodachrome films, the Kodachrome 25 is superior to the two others. So it is up to the photographer to select the right film for the right task.

This also applies to the slide films developed in the E-6 process. Kodak Ektachrome films are available at speeds of ISO 50/18°, ISO 100/21°, ISO 200/24° and ISO 400/27°. The ISO 50 and 100 films are marketed as HC film, and are distinguished by particularly strong, rich colours to meet general trends. At the top of the speed range is Kodak's professional film, Ektachrome P800/1600 which has a variable speed. The whole

film does, of course, have to be exposed at the same speed rating. Although Ektachrome P800/1600 and the T-Max P3200 are only supplied in professional form, the professional version of other films is simply a parallel product to the amateur stock.

Professional films are no better than the others, they are only tuned more precisely to the needs of professionals. This means that films with the same emulsion number don't vary in their colour reproduction. This is important for long sequences of a single subject in the same light with studio flash units for example. This characteristic of professional films is less important to amateurs who shoot many different subject on one film, when the intensity and colour of the light are changing constantly. Differences in the colour reproduction of amateur films with the same emulsion number are unlikely, but the possibility can't be excluded altogether.

In addition, professional films are designed to be used quickly. They are 'ripe' when delivered, and this can only be maintained if they are stored in cool conditions, exposed quickly and developed as soon as possible. So there is no real reason for amateurs to use professional films, unless they're on special offer or you're really working under professional conditions.

Specialist films - for exceptional situations

The specialists amongst films are used very rarely, but if you do need to use one occasionally, they're to be found in the range of large manufacturers like Kodak.

These include, amongst others, tungsten light slide films which deserve to be much more popular. Kodak Ektachrome 50T and Ektachrome 160T (T is short for Tungsten) are sensitised in such a way that they reproduce colours correctly even when the subject is lit by photo lamps which make daylight films give a yellow cast. Artificial light films exposed with daylight, on the other hand, show a distinct blue cast. Other specialist films include infra-red and duplicating films.

ACCESSORIES WELL WORTH LOOKING AT!

OP/TECH

The world's most comfortable cameras, bag and tripod straps (binoculars too). Op/tech has a built-in weight reduction system that makes equipment feel 50% lighter and 100% more comfortable. From the famous 'Pro-Camera Strap' to the 'Bag Strap' and the 'Tripod Strap', the style, colours and comfort which along with the non-slip grip, ensure that you have a wonderful combination of comfort and safety.

BAG STRAP

The **OP/TECH USA Bag Strap** is the answer to the problem of carrying a heavy bag for extended periods of time. By combining the patented weight reduction system with the Non Slip Grip™, you have the perfect strap for camera/video bags and cases as well as garment bags. Adjustable from 29" to 52", this strap is one of a kind. You will feel the difference!

STO-FEN

The ultimate lightweight diffuser system for high powered modern flashguns. Sto-Fen offers the 'Omni-Bounce' for overall soft diffusion – often called the "softie" – which weighs in at just 15 grams and the 'Two-Way' Bounce Card for those who prefer to direct diffused light from their flash. The 'Two-Way' only weighs 25 grams, so it adds almost nothing to the overall weight of the flash. Sto-Fen are the lightest weight, most effective flash diffuser products on the market today.

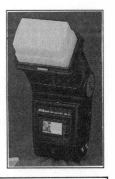

PELI-PELICAN CASES

Watertight and airtight to 30 feet for the ultimate in protection. Constructed of light weight space age structural resin with a neoprene "O" ring seal and exclusive purge valve. Supplied complete with pre-scored pick n'pluck foam or padded dividers. Also includes locking flanges, massive multiple latches for absolute security and best of all, a comfortable molded grip handle.

JERSEY PHOTOGRAPHIC MUSEUM

OVER 1000 CAMERAS AND PHOTOGRAPHIC
ACCESSORIES ON SHOW FROM 1850 TO THE PRESENT DAY

EXHIBITION OF PHOTOGRAPHS IN THE GALLERY
CONSTANTLY CHANGING

OPEN 0900 - 1700 HOURS MONDAY-FRIDAY
CLOSED PUBLIC HOLIDAYS
ADMISSION CHARGE - £1

THE PHOTOGRAPHIC MUSEUM IS LOCATED IN THE CHANNEL
ISLANDS BETWEEN ENGLAND AND FRANCE IN THE LARGE
HOTEL DE FRANCE, CONFERENCE & LEISURE COMPLEX
ST. SAVIOUR'S ROAD, ST. HELIER,
JERSEY, C.I. JE2 7LA
TEL. (01534) 614700 FAX (01534) 887342

For a complete list of the many
Hove Foto Books
and User's Guides
for Modern, Classical
and Collectors' Cameras,
write to:-

Worldwide Distribution:
Newpro (UK)
Old Sawmills Road
Faringdon
Oxon
United Kingdom
SN7 7DS
Tel: (01367) 242411
Fax: (01367) 241124

Or from the Publishers:
Hove Foto Books
Jersey Photographic Museum
Hotel de France
St. Saviour's Road
Jersey
Channel Islands
JE2 7LA
Tel: (01534) 614700
Fax: (01534) 887342

AMPHOTO
BOOKS FOR PHOTOGRAPHERS

50 Portrait Lighting Techniques
for Pictures That Sell
REVISED EDITION

The Field Guide to
Photographing Flowers

Understanding Exposure
HOW TO SHOOT GREAT PHOTOGRAPHS

The Field Guide to
Photographing Landscapes

JUST A FEW TITLES FROM THE EXTENSIVE LIST
OF "WORKSHOP" BOOKS FROM THE WORLD'S
BIGGEST AND BEST PUBLISHER OF HIGH
QUALITY, BUT AFFORDABLE PHOTO BOOKS